D0744172

Politics and Theology in Chinese Contemporary Art

Huang Zhuan

POLITICS AND THEOLOGY IN CHINESE CONTEMPORARY ART

Reflections on the work of Wang Guangyi

Cover
Wang Guangyi,
Things-In-Themselves, 2012

Design
Marcello Francone

Editorial coordination
Vincenza Russo

Copy editor
Emanuela Di Lallo

Layout
Antonio Carminati

Translation
Jeff Crosby
Julia Heim

First published in Italy in 2013 by
Skira Editore S.p.A.
Palazzo Casati Stampa
via Torino 61
20123 Milano
Italy
www.skira.net

Printed and bound in Italy. First edition

ISBN: 978-88-572-2143-4

Distributed in USA, Canada, Central & South
America by Rizzoli International Publications, Inc.,
300 Park Avenue South, New York, NY 10010,
USA. Distributed elsewhere in the world
by Thames and Hudson Ltd., 181A High Holborn,
London WC1V 7QX, United Kingdom.

The two sections of this book ("Politics in Art"
and "Theology in Art") have previously been
published separately in Chinese and English by
the He Xiangning Art Museum and OCT
Contemporary Art Terminal Edition, Shenzhen,
China, 2008 and by Today Art Museum Edition,
Beijing, China, 2012. They have been republished
in this work with additions by the author.

Photo credits
© 2013. DUfoto / Foto Scala, Firenze: 82
© 2013. Foto Scala, Firenze: 104, 105, 106,
107, 114
© Bettmann / CORBIS: 81, 134
© Hulton-Deutsch Collection / CORBIS: 80, 81
© dpa / dpa / Corbis: 162
© Photo Art Resource / Scala, Firenze: 154
© Photo by Eliot Elisofon / Time Life Pictures /
Getty Images: 163
© Photo Scala, Firenze / Fondo Edifici
di Culto – Ministero dell'Interno, detail: 160
© Photo Christopher Makos 1982
makostudio.com: 38

Contents

10 Foreword
Marko Daniel

16 Between Historic Reality
and Transcendence. Huang Zhuan
on Wang Guangyi
Demetrio Paparoni

Part One: Politics in Art

23 Contemporary History in Chinese Art
and Subjectivity
37 Politics in Art
37 The Misread *Great Criticism*
44 A Dangerous Premonition
45 An Analysis of the System
69 Materialist Theology
79 *Cold War Aesthetics*

Part Two: Theology in Art

103 The Problem of Theology in Western
Art History
107 Cultural Utopia
119 Image Correction: A Revelation
134 *Mao Zedong: AO*
146 A Variant Pop
161 The Thing-in-Itself
177 The Artist's "Sacred Books"
181 Conclusion

185 Acknowledgements

188 Notes

This book is dedicated to my suffering mother
May she rest in peace in Heaven

Foreword. Marko Daniel

Looking on back on Huang Zhuan's writings about art one notices that in a career spanning thirty years he has not just participated in the development of contemporary Chinese art from close up and from what is still considered its very starting point, but observed it at the same time from a particular point of view. More than an eye-witness account of the evolution of the art world in China, his writing transcends it and offers a reflection on modern art per se, and on the history of modern thought. European philosophy and European and American art are the cornerstones for quite a radical rejection of any inward-looking concern.

The philosophers Huang Zhuan references span centuries of Western thought; from Plato and Aristotle, to Kant, Hegel, Nietzsche, Heidegger, Derrida, Baudrillard and even the political philosophies of Engels, Marx and Althusser. The inclusion of continental and analytic philosophers, phenomenology, metaphysics, nihilism, semiotics, deconstruction and political, cultural and religious philosophy allows Zhuan to map out the Western philosophical framework behind Wang Guangyi's convergent and divergent artistic pursuits. This philosophical backdrop provides the reader with a critical key for interpreting Wang Guangyi's art. Zhuan is interested in the way Plato and Neo-Platonic theology helped to inform the mystical symbolism within series like *Frozen North Pole*, and how the Hegelian principle of absolute spirit merges with Nietzsche's artist-as-superman in Guangyi's empirical positioning of transcendental aesthetics. Huang Zhuan's investigation into Kant's "thing-in-itself" shows how the artist uses philosophy to leave space for the unknowable within his work. In terms of art history, both Huang Zhuan and Wang Guangyi reference Gombrich and his concept of schema and correction as an important reference point in Guangyi's shifting aesthetics, as the artist sought to eliminate the emotional when confronting social and cultural issues in his works.

From Renaissance art and early modern thought to Duchamp, Warhol and Beuys, the axes of reference for Huang Zhuan are resolutely Western and function as poles for understanding the work of Wang Guangyi in this book. They also serve to map out the divergences and coherences in the development of modern art: detachment and investment, coolness and heat, irony and symbolism, cynicism and mysticism, corporeality and spirit. All of this takes place in relation to an engagement with the tensions between conceptual approaches and the inherent materiality of art, even as practices sought to evade this materiality. This tension is discussed with great insight in relation to the difficulty of fixing, preserving, archiving, documenting, in fact even seeing the work of an artist like Beuys now, as his place in history is consolidated whereas the material presence of his work fades. While Huang Zhuan moves between these reference points with ease, in this book they derive their relevance from their precise application to the work of Wang Guangyi, an artist who shares a remarkable intellectual closeness with the author.

Wang Guangyi was one of the very first contemporary Chinese artists whose work I encountered at a time when the European art world made its first slow and awkward advances into territories beyond. His inclusion in the 45th Venice Biennale, twenty years ago, signalled the start of his international career. That same year, 1993, he also took part in the *China Avant-Garde Exhibition*, tour-

ing in Europe, in *China's New Art* at the Museum of Modern Art, Oxford, and his work was showed in Hong Kong and Australia. His paintings of that time, in particular the *Great Criticism* series, hit the cultural sweet spot in terms of being utterly open to Western viewers while seeming inexorably Chinese. Their style was clearly in a Pop idiom, their subject matter included familiar consumer brands (cigarettes, soft drinks, electronics) and all this came packaged in the iconography of the Great Proletarian Cultural Revolution with serried ranks of young pioneers. That their fists were as likely to hold pens as revolutionary flags only made them more ironically attractive. The forward march of this Political Pop seemed unstoppable. The art was bold and suggestive, compositionally and chromatically, in a way that seemed retro-Chinese with Western attributes plus a remarkable sense of humour. So what if the entire vocabulary of revolutionary poster art was itself an import into China from their great Soviet comrades? Such details did not distract from their dynamically diagonal advance. It was not that this art-historical knowledge was unobtainable but, on the contrary, that the combination of art-historical recognizability and ironic detachment let the works of these artists, Wang Guangyi foremost among them, enter our consciousness with consummate ease. In a move best understood topologically as a mutual interpenetration, the works carried familiar elements that let them cross into our world as if the commercial products depicted in decontextualized random isolation in those paintings heralded the way Western consumer culture was to sweep China. From today's perspective, of course, we are looking back on a moment of frisson in a continuum of historical and contemporary cultural exchanges.

What Wang Guangyi needs now is not another text that positions him as the poster boy of Chinese art, especially that Political Pop of the 1990s in the context of which he first became known in Europe, but one that explores his work in a far more nuanced way. This would include an analysis of how complex the situations were in which he rose to prominence, his role in the various modern art and avant-garde movements of the 1980s, the opening and closing of post-cultural revolution society, and, not least, the fundamental socio-economic changes with all their social and ideological continuities and discontinuities. We only need to think of Wang Guangyi's powerful if elusive motto of "clearing out the humanist passions" which he coined around 1989 to describe his transition from the modernism of the '85 New Wave movement to the *Post-Classical* paintings and then on to the *Great Criticism* series. Huang Zhuan's analysis pinpoints how sophisticated Wang Guangyi and other artists and intellectuals at that time were when it came to understanding their own socio-economic situation and the complex traffic of art-historical concepts in which they engaged.

At first, I perceived both the humour and the references to an incipient culture of consumption as critical of the Chinese regime. While that kind of reading was widespread, closer readings of the works and the history of their making suggest another story. Taken in the context of the artist's preceding works, in particular the *Frozen North Pole* series and the *Post-Classical* works, it becomes clear that Wang Guangyi's adventures in Pop Art were far from a first and superficial encounter with recent Western art. These earlier works, Wang Guangyi's own comments and Huang Zhuan's interpretation of them now suggest instead that Wang Guangyi read European classical art as a strategic denial of the superficial emphasis on subjectivity that fuelled the '85 New Wave expressionism. This way of looking at Wang Guangyi's Political Pop works helps understand what Huang Zhuan considers to

be among the key characteristics and key differences from Western Pop, which he at one point defines as being about respectively rearranging or removing meaning, in particular a rearranging of meaning through the interweaving of Chinese political and Western consumer history.

At this point, it is useful to point out the intellectual closeness between author and artist, Huang Zhuan and Wang Guangyi. The readings offered by Huang Zhuan in this volume are not just perceptive and profound but crucially depend on a long and shared trajectory of intellectual enterprises, in their respective domains. They share a remarkable knowledge of European intellectual history that each in his own way brings to bear on contemporary art. Obviously, this did not spring fully formed from their minds but was built and honed over time and through practice. From early expressionistically painterly works by Wang Guangyi to neo-classical and Pop canvases with added distancing devices (grids, lines, inscriptions) a scholarly engagement emerges as well as a formal, stylistic and art-historical appropriation. Perhaps the process is better described as one of testing relationships between art and mind over time, for both Huang Zhuan and Wang Guangyi, which makes this book an intriguing encounter of the two, one in an ongoing series of such encounters.

While reading the text, and the images that it deals with, I stumbled across another facet of this cross-cultural process: my own place in it. As Huang Zhuan sums up the history of European thought, he posits the Enlightenment as a process of radical secularization, placing human beings rather than god at the centre of the system. We might be accustomed to thinking of the legacy of this history in terms of lofty ideals, say progress and democracy, concepts whose absolute and universal status postmodern criticism has profoundly challenged from within; but what Huang Zhuan is doing here is more unsettling. His account questions the truisms we Europeans hold about ourselves and our history: rather than, say, democracy and progress he sees totalitarianism and conservatism as the dominant characteristics of modernity. I insist that this is not an accident or a misreading of the European tradition but a signpost to one of the most intriguing ways of getting know about another culture. In my conversations with Huang Zhuan he has startlingly realigned my understanding of European culture, specifically since the Enlightenment, from Goethe to Danto. And it is in this realignment of truisms, and in the act of being startled, that I continue to gain a deeper understanding of the cultural framework in which he operates. I now realize that the very act of tripping up over a subtly or fundamentally different reading of matters previously thought self-evident is what makes me stumble forward into the equally complex intellectual universe occupied by this generation of thinkers and the historical processes through which they formed themselves.

Equally remarkable is the engagement with the history of European art and thought in Wang Guangyi's work – from neo-Platonic philosophy to, in particular, Ernst Gombrich's theorization of modernity. Sitting at the crossover of art, politics and philosophy, Wang Guangyi, in the 1980s and 1990s in particular, saw in his work the struggle to find a framework for being contemporary. Contemporaneity is not simply the product of calendar time, but conceptually is about what characterizes art and makes it distinct from the tradition of modernity. In the social, economic, political and cultural context of China in the 1980s, Wang Guangyi sought to differentiate modern and classical art from that which directly engaged with contemporary life. It strikes me that in the early works produced in the relative isolation of his time in China's far north (Harbin must have felt like the "Frozen North

Pole" after his time as a student at Zhejiang Academy, nearly two and a half thousand kilometres further south) we can see that there is an existential void at the heart of the artist's engagement with contemporary life. Wang Guangyi, put simply, was working through art history, and in particular the history of Western art, to find a place for subjectivity. He himself identified this when he periodized his early work in an interview in 1989, quoted in this volume below by Huang Zhuan. From an emphasis on the humanist spirit, then considered a radical alterity in collectivist socialism, he moved to the cultural correction of art history, and finally on to the above-mentioned "clearing out of humanist passions".

There is a strongly formalist element to this and I am reminded of the way the term "formalism" had been used as an insult already in Soviet Russia, as a way of attacking art that was distant from real life. Of course in that context real life meant the obedient glorification of the worker and the party, which could be considered enough to turn anyone off real life and onto formalism. With the formalism in Wang Guangyi's work, in particular the "corrections of art history", there also came a dualism: formalism of the grid patterns, say, that were superimposed over paintings (*Red Squares*) or constituted by arrangements of objects (*Temperature*). Dotted lines, letters and grids over figurative paintings forced flatness over depth, over perspectival space and maintained an active tension between depth and surface. These are games of classic modernism, but also showed Wang Guangyi's "infatuation" or "enchantment" with Western classical painting (from the Renaissance to the Picasso of the classical period). But those models or reference points needed correction, as Wang Guangyi said: the artist needs first to "perceive and analyse the specific cultural atmosphere of his surrounding social environment" in order to be contemporary.

In other words, Wang Guangyi arrives at an acute analysis of contemporary life via classical European painting. What his process of painterly engagement with this art history demonstrates is that it was never simply a formalist conceit but rather a much deeper-seated enactment of avant-garde art strategies familiar from Duchamp, Dada and, indeed Pop Art. The work of the artist here goes hand in hand with deep access to an intellectual tradition. In fact, the very concept of cultural correction is a radical riff on Gombrich's account of stylistic innovation as the correction of traditional schemata. For Wang Guangyi, and for Huang Zhuan, these European traditions were never simply aesthetic-artistic but always inseparably bound up with philosophical, social and political discourse. So when Wang Guangyi describes his own artistic development in formal terms by virtue of the development of artistic language, I see that the apparently "neutral standpoint" to which Wang Guangyi aspires is in fact a nuanced understanding of the role of the subject in modern and contemporary society. Far from being divorced from real life, Wang Guangyi maps out the trajectory from socialism to consumerism, but entangled with the history of ideas, and especially that history of ideas as it becomes embodied in and analysed through art.

Formal, artistic breaks then pinpoint discontinuities both within the traditions that are referenced and in the transcultural engagement with those traditions. That is how Huang Zhuan in his essay takes *Mao Zedong: AO* as a transitional artwork marking Wang Guangyi's transformation from a cultural utopian to a contemporary artist. It is also how Huang Zhuan sees in the works of the *Great Criticism* series not only a consolidation of Wang Guangyi's position as an artist concerned with the contemporary (with the contemporary life of people and his making art about this) but also what he calls a "massive trap for our understanding of

his art". These works are so obviously about politics and consumption, about the massive changes affecting society and the individual's engagement in social, political and economic processes. Yet, Huang Zhuan makes it his case that they are to be understood as articulations of a conflict between the transcendental and empirical worlds. As a child of the Cultural Revolution, Wang Guangyi grew up with an unquestioned belief in Mao, something the he himself openly acknowledges. "Even though I see him rationally today, I still have this strong image inside me. Everyone needs something to believe in. For me Mao was my belief. To me Mao was like Christ was for Christians. Christ cannot be doubted; and Mao, you had to believe him" [Andrew Cohen, "Reasoning with Idols: Wang Guangyi", in *Art Asia Pacific* 77, March–April 2012, http://artasiapacific.com/Magazine/77/ReasoningWithIdols-Wang Guangyi]. What this makes me realize is that the art-historical trajectory Wang Guangyi took was no accident but essential to being able to produce works that combine the simultaneous air of neutrality or detachment with a profound political or social criticism. The internationally recognizable language of these works remarked upon at the beginning of this foreword is thus indispensable to their functioning. Again, this is a thematic that Huang Zhuan analyses carefully when he describes Wang Guangyi's attention to the "ideological systems" in "international politics" or the way in which he extended "artistic problems into the fields of political and social problems" and "domestic problems into the international field".

Thus we end up again with an intimately intertwined view of the range of Wang Guangyi's theoretical engagements with his artistic production, which is not so much a time-lapse processing of European art history from the Renaissance to today but a move from, say, referencing Kandinsky and Mondrian as neo-Platonic artists to Duchamp as a post-Hegelian. If we think of Duchamp as providing the central hypotheses for contemporary art in the 1960s and 1970s, then Beuys offered the second pole through engagement with social reality but also a continued engagement with myth.

This for me further explains the relationship in Wang Guangyi's work between Mao Zedong as a historical figure and a mythical icon. Crucially, Wang Guangyi talks about his own "cultural reverence" for Mao Zedong in this context in a way that is not all that different from his self-confessed "infatuation" with Western philosophy and classical painting.

Whereas Beuys is usually seen as representing that spiritual end of the contemporary art spectrum and Warhol the materialist end, Wang Guangyi found inspiration in Warhol's "transformation of ordinary objects into sacred objects" and claimed he did the reverse with his images of Mao, restoring a god to a man.

Duchamp, Warhol and Beuys, then: concept, material and spirit. Kant, Mao and Nietzsche. The references to art, philosophy, politics and history in this study of Wang Guangyi by Huang Zhuan come thick and fast as artist and author jointly epitomize the prodigious intellectual and cultural enterprise of contemporary art in China in the last three decades.

Marko Daniel is a curator at Tate Modern, London

Between Historic Reality and Transcendence
Huang Zhuan on Wang Guangyi. Demetrio Paparoni

Politics and Theology in Chinese Contemporary Art: Reflections on the Works of Wang Guangyi is a fundamental text for understanding an aspect of contemporary Chinese art which to us may wrongly seem like a revisiting of themes already present in twentieth-century Western art – Pop Art and Conceptualism in particular. Huang Zhuan is one of the most acute and original thinkers in the contemporary Chinese artistic scene. As he will explain in these pages, since the second half of the 1980s Chinese artists have had an ambivalent relationship with Western culture. If, on the one hand, there has in fact been an opening up, on the other hand it is also true that the attention to maintaining certain identifying characteristics has resulted in the creation of significant defence mechanisms. The critical scene in the last thirty years, characterized by a tendency towards the deconstruction of the systems that have marked the history of modernity, has provided the premise for an encounter between once distant cultures on themes of subjectivity within artistic creation that we see in Huang Zhuan's theses.

In the history of modernism a key figure who bore witness to the identification of the critic with an artist or with a movement was Charles Baudelaire. In the second half of the nineteenth century Baudelaire maintained that the art critic must be "partial, passionate and political, that is to say, he should write from an exclusive point of view, but a point of view that opens up the widest horizons". Baudelaire's famous affirmation, which manifests the need to merge the partiality of the critic with the introduction of hermeneutic operations, was furthered by André Breton, who in 1920 declared that "criticism will be love or will not exist". Breton identified with the artists that he loved the most until he himself became the living embodiment of Surrealism. The risk of this approach to art lies in the fact that partiality diminishes the possibility for interpretation, weakening the credibility of the critical analyses. The act of loving the artists or movements they identify with may impede the critics from looking beyond these movements, resulting in their evaluation of every artistic and cultural expression as unique. The critic is thus prevented from acquiring an objective method.

The demand that critics adhere to a method based on objectivity was articulated by Clement Greenberg in the 1950s. Greenberg tried to position Jackson Pollock's "action painting" and "dripping" within an objective frame. Greenberg's "scientific" desire was, however, only a pretence. The "scientific" approach of this American critic hid within it a partisan and politicized vision that tended to argue for the superiority of American art over European art. As a result, he stood in the way of an adequate interpretation of the contemporary artistic phenomena of Action Painting. For example, Greenberg, in his defence of American art in the 1950s, maintained that Pollock was "the greatest painter since Picasso", and then raised the ante by affirming that Pollock "takes Picasso-like ideas and makes them speak with an eloquence and an emphasis that Picasso himself wouldn't even dream of giving them". Despite dealing with paradoxical and critically unsupportable affirmations, their propagandistic effect produced results so powerful that even today their echoes still remain. Proof of the fact that – as the work of Wang Guangyi also reveals – if they are well studied, the strategies of propaganda always produce their effect.

The tendency to mark the boundaries within which cultural phenomena are positioned, typical of modern and contemporary criticism, was surpassed in the 1990s by Arthur C. Danto's explosion onto the international scene. In fact, the American philosopher and art critic approached artistic phenomena through the lens of analytical philosophy. Making reference to Danto helps us understand Huang Zhuan's method of inquiry, in particular when he analyses the work of Wang Guangyi. Like Danto, Huang Zhuan reads works of art with a philosophic eye, placing himself in a middle ground between image and thought. Like Danto, who stressed the supremacy of the concept over the visual representation in his analyses of Warhol and modernism, Huang Zhuan interprets Wang Guangyi's works and Chinese artistic events through the philosophic thought from which they might be said to arise. While Danto identifies the historic significance of American Pop Art in Warhol's *Brillo Box*, Huang Zhuan proposes a new reading of the concept of Pop through the work of Wang Guangyi, who emphasizes the contraposition of the external world and transcendence.

Wang Guangyi's most famous pictorial cycle is *Great Criticism.* In this series of paintings the artist places Maoist propaganda images together with the most famous Western logos. The objective is to show how both are cases of propaganda that use hidden persuasion. Huang Zhuan sees in these works the successful attempt to separate these objects from their common use in order to place them within the auratic dimension of sacred art. In bringing to light the relationship between the image and its model, between appearance and the reality that lies beyond appearance, Wang Guangyi introduces the concept of transcendence and the philosophical and theological questions closely tied to it. It is obvious therefore that, in dealing with such questions, the artist as well as the critic have felt the need to confront not just the tradition of Chinese cultural thought, but themes of the Western philosophic tradition, from Plato to Kant and Schopenhauer to Nietzsche. This train of thought has led Wang Guangyi to make the perceivable world which is positioned in time interact with that which goes beyond time, the eternal and transcendental.

Huang Zhuan maintains that the tension between the perceivable world and that which lies beyond time is unrelated to Warhol and American Pop Art, which, by *creating* the images they appropriate, fix themselves in a specific time. Warhol makes reference to Byzantine icons and to themes of death within the subjects of his works, like the electric chair, automobile accidents and skulls, which evoke a spiritually charged silence. In Warhol's work we find Christian crosses, hands joined in the act of prayer, portraits of the Virgin Mary and Christ, and interpretations of Leonardo's *Last Supper*. But for Huang Zhuan and Wang Guangyi these subjects are not enough to carry the work beyond time. With a Kantian approach Huang Zhuan and Wang Guangyi read art through the noumena; in art they see the visual manifestation of phenomena referred to a reality that is beyond perceivable knowledge and of which an exact definition cannot be given in theoretical terms.

But let us return to Warhol. For Wang Guangyi, Warhol's images are "the product of the universal decline of spirituality". This reflection reminded me that in 2006 in Rome a show was organized dedicated to Andy Warhol and his relationship to the spiritual. The title of this exhibition, curated by Gianni Mercurio, was *Pentiti e non peccare più!* (Repent and sin no more!), a phrase in the Gospel uttered by Jesus, a phrase that Warhol had made his own, transcribing it in 1985 by hand on canvas. In the introduction to the show, Gianni Mercurio references

the book *The Religious Art of Andy Warhol* by Jane Daggett Dillenberger, emeritus professor of visual arts and theology at the Graduate Theological Union of Berkeley, in California. The book brings to light the spiritual and religious aspects of the work of the American Pop artist. In my contribution to the same catalogue, I noted that the electric chair, more than anything else, is proof of the conflicting relationship between man and God. I wrote: "The death penalty is, in fact, a huge contradiction for Christians. That a community should decide that guiltiness can be atoned for through ritual death indicates that man can decide to give or take life from his kind, a right which in the Sacred Scriptures is reserved solely for God". My conclusion was that when Warhol silkscreened the electric chair or the atomic mushroom cloud on a canvas, he had in mind the question of the sacred in relation to the presumption of man, who substitutes himself for God in deciding the fate of his fellow kind. This was not a risky thesis, as evidenced by what Jean Baudrillard and Arthur C. Danto wrote in the same catalogue. Danto in particular, returning to a theme which was dear to him, warns: "With the *Brillo Box* Warhol showed how two objects can have an identical exterior, and be, not only different, but the most different of different. In terms of the philosophy of art this implies that it is possible to find oneself in the presence of a work of art without realizing it, because we wrongly expect that in being an object of art, it must carry with it some sort of grand visual difference. With things that are related to the sacred, to religion, the same can happen: we expect that they appear significantly different from ordinary things, while in reality it is their ordinariness that masks, so to speak, the appearance".

It is no coincidence that Danto's words were called to my mind as I read Huang Zhuan's book. In the winter of 2012 I went to visit Danto at his house in New York. As always, our meeting turned into a huge discussion. The conversation, which continued via email in the following days, resulted in an interview that was published in the April issue of that year in the magazine *ArtChina*. During that meeting I said that what he had written about the sacred in his text on Andy Warhol (which I cited earlier) could also be said for the work of Wang Guangyi. In other words, the misinterpretation of Wang Guangyi's work, which in the West is still erroneously being read as Pop Politics, is the same misinterpretation that Warhol's work is still the victim of today, as it is often wrongly considered ideological art, and the expression of materialism. What's admirable in Huang Zhuan's book is the effort to understand the "self" through the "other", where the "self" is Wang Guangyi and the "other" is Andy Warhol or Joseph Beuys, two artists with very different visions who, lest we forget, collaborated nevertheless. In analysing the unifying themes in Wang Guangyi's art, using, at times, the filter of the history of Western thought, Huang Zhuan relates to the whole of the work and not just to its parts.

Wang Guangyi's work is very diverse in terms of form, but all of it can be traced back to the search for transcendence. Huang Zhuan explains that the artist, in the first phase of his work, tended towards idealization and sentimentality, which he later abandoned, removing every human passion. Thus, he chose to separate every form of emotional involvement in order to observe reality in a disenchanted and evaluative way. This choice, as Huang Zhuan points out, is evident in the *Inflammable and Explosive* series (1989) wherein the components are not reducible to a known artistic iconography nor to any actual historical event: the artist does not programmatically narrate anything nor does he express judgements, and yet he photographs reality and gives it back to us in a way that is al-

most more authentic than reality itself. In this way, in his descriptions of social phenomena that have accompanied the history of recent years, Wang Guangyi positions himself objectively. This approach finds confirmation in the Western social science methodology elaborated on by Max Weber: for the German sociologist, social science had to be completely evaluative to avoid the tainting or altering of investigations due to ideological or political interpretations. This led Weber to maintain that university studies should only put forth objective analyses, which could not be used for propagandistic ends.

From the 1990s on, Wang Guangyi planned to begin an analysis of the ideological systems that govern the United States and China in particular. The cycles *Great Criticism, China Thermometer* and *Comparison between Chinese and American Temperature* come out of this time. Slowly his analyses broadened to include the international situation in all its complexity. Huang Zhuan's book and the work of Wang Guangyi allow us to see the juxtaposition of two ideologies within China in the 1990s: communism and consumerism. Huang Zhuan draws on this to show that Wang Guangyi's dialectics makes opposites speak to one another. In this way his research shifts from one opposition that plays out entirely in reality (an opposition of a historic, social and political nature) to an opposition between concreteness and ideality. The artist takes the discourse to the metaphysical level, which he defines as "theological" and "transcendental". It should be noted however that he does not use the term "transcendental" necessarily in the Kantian sense, that is, not as an a priori condition of knowledge, but as a synonym for transcendent. Thus, for Wang Guangyi, the dualism is identified with the opposition between the material and the transcendent world, which here is indicated by the Kantian concepts of "thing-in-itself" and the "idea of the divine".

When Huang Zhuan examines the dichotomy between ideas and perceivable things, between the visible world and the intelligible one, the question of dualism assumes the dimension of an historic reconstruction of Western thought. By reminding us that, within such a frame, art has been viewed platonically as an imitation of the real, Huang Zhuan shows the meaning of the Renaissance shift wherein the work of the artist is compared to the divine act of creation. Furthermore, Huang Zhuan emphasizes that for Wang Guangyi there exist "two worlds, and it does not matter if they are real or imaginary: one is classical, ordered, rational and transcendental; the other is contemporary, chaotic, irrational and tied to notions of the perceivable. The classical world is connected to religion, myth, prophecy, heroism and enlightened faith, while the contemporary world is casual and idolatrous, realistic and cynical. In his experience both of these worlds exist, and his art is comparable to a game in which the pieces on the chessboard lie in opposition".

Since 1984, a growing number of the most important writings on Western art history have been translated in China, and Gombrich's work is chief among them. Gombrich's idea of the "pure eye" – according to which our perception preliminarily corrects the images that we observe – requires artistic language to be conceptual. These texts have provided Wang Guangyi the theoretical basis for elaborating his *Post-Classical* painting series, which he would complete in the second half of 1986. In 1984 Wang Guangyi began his artistic adventure with the Northern Art Group whose objectives were delightfully idealistic. With regard to this phase, Huang Zhuan affirms that Wang Guangyi was an utopian at the time: he did not believe that the scope of art was the form, but rather the realization of a new culture and a new spiritual mode capable of leading to the search

for Truth. The cycle of paintings *Frozen North Pole* (1985) represents the visual equivalent of this kind of utopian manifesto. The technique is classical – something that was fairly atypical in the Academy of Fine Arts where he was enrolled – and the work, in its totality, seems supported by an architecture in which each element has a specific position within a hierarchical order. Starting from these positions, Wang Guangyi reaches the conclusion that pictorial language is characterized by a specific technique (material component, variable) and scheme (aprioristic component, invariable). Following this method he developed an approach to artistic practice that was increasingly analytic, which led him to transition from his initial symbolic-classical phase to his present position, characterized, as I have said, by the objective description of the phenomenon-essence duality.

A fundamental stage in the work of Wang Guangyi is marked by the *Mao Zedong* cycle, created at the end of the 1980s. Huang Zhuan maintains that this cycle expresses the artist's will to "logically solve the issues of the transcendent sphere within the confines of the empirical world". According to Zhuan's interpretation, Mao "is the only idol in the contemporary world who can reconcile the empirical and the transcendent world, rationality and faith", apparently resolving the irresolvable contradiction of the two polarities. Furthermore, Wang Guangyi's entire body of work, as argued in this book, tends to expound the tension between historic reality and transcendence within the empirical plane.

Demetrio Paparoni an is essayist and independent curator. He has edited the monograph *Wang Guangyi, Works and Thoughts 1985–2012* (Milan: Skira, 2013)

Preface to Huang Zhuan, *Politica e teologia nell'arte cinese contemporanea: Riflessioni sull'opera di Wang Guangyi* (Milan: Ponte alle Grazie, 2013)

Part One

Politics in Art

Contemporary History in Chinese Art and Subjectivity

The way in which you approach the value of contemporary Chinese art depends entirely on the cognitive map you use. Two contrasting maps emerged in early-nineteenth-century Europe. One was the world map drawn by Hegel, based on the European spiritual movements in which China was merely a foreign land with no history; everything that happened in China remained disconnected from those spiritual movements. Modern cognitive cartographers who redraw this map, post-colonialists of different varieties, depict this spiritual foreign land as an "other" subjected to the movements of the centre. They thus mirror the relationship between China and the surrounding areas depicted in the ancient Chinese conceptual model. The other map is the world map drawn by Goethe, a cognitive map laid out along the coordinates of mankind's largely shared ideals. In this map, both in ancient times and today, China and the rest of the world participate in a large web that assimilates them and highlights the constantly intersecting movements between different cultural subjects, just like the imagery he created in later works such as *West-Eastern Divan* and *Chinese-German Book of Hours and Seasons*.

I would like to use Goethe's map to depict the modern art movement that has taken place in China, viewing it as both a positive reaction to the European modern art that has developed since the nineteenth century and as a product of China's subjective movement of self-rediscovery within its own history of modernization. China's modern art movement began in the early twentieth century, not long after modern art emerged in the West. In the 1920s and 1930s, many artists returning from studies in Europe brought back the modernist paintings styles they learned there, transplanting and disseminating these new artistic concepts and forms in China through the formation of painting schools. In Shanghai, it began with the Heavenly Horse Society founded by Jiang Xin, Ding Song, Wang Yachen, Liu Yanong, Zhang Chenbo, Yang Qingpan and Chen Xiaojiang; later there was the Storm Society founded by Pang Xunqin, Ni Yide, Liang Baibo, Yang Qiuren and Wang Jiyuan. In Guangzhou (Canton), there was the Chinese Independent Art Association founded by Zhao Shou, Liang Xihong, Fang Rending and Li Zhongsheng. Modernist painting came into vogue in China, but the glory days were short-lived – the eruption of the war with the Japanese and the civil war that followed ensured that this early modernist art would not last. After roughly half a century the experiment could finally begin again. The year 1976 marked the end of the Great Proletarian Cultural Revolution. This leftist political movement, viewed in the West as a radical one, excluded and distorted the spread of Western modernist art, and it was not until the late 1970s and early 1980s that China's modern art movement began again under the political slogan declaring the "liberation of thought", though this movement had a completely different historical context and content from that of the West.

Europe's modern history, which began in Florence in the fourteenth century, together with the "discovery of man" and the "rebirth of art" through the Re-

naissance, and through the eighteenth-century Enlightenment and the development of scientism in the nineteenth century, opened the doors to modernity. Through the efforts of Descartes, Leibniz, Vico, Kant and Hegel, the rationalist system, which put man rather than God at its centre, began to gradually take shape. Through its practice it revealed its high levels of totalitarianism (the establishment of strict modern organizations and systems) and conservatism (determinism with a refusal of critical thought). The modernist art movement was produced within these modern cultural values yet it also served as a resistant reaction against a systematized secular civilization; it was a self-contradicting movement that constructed man's subjectivity while simultaneously deconstructing it. Its experimentalist attitudes and anarchic modes of thought caused a pervasive sense of crisis within the movement and drove it to the antithesis of its idealist origins – the various forms of postmodernism and theories of the "end of art" are theoretical reactions to this crisis.

Instead of a pure formalism, the modernist art experiments that began anew in 1980s China attempted to establish an age of enlightenment with man at its centre. Though its weapons were the various modernist art forms, the formal and semantic discrepancies imbued the movement with a paradoxical character. A serendipitous exhibition that took place in Beijing in late 1979 became its starting point. The *Stars Art* show was a spontaneous street exhibition organized by a group of young amateur painters, who produced a slogan that may now seem quite strange: "Kollwitz is our banner, Picasso is our pioneer". This street exhibition was ultimately banned (though a year later it was approved and shown at the National Art Museum of China). Their slogan, which blended political aims with formalism, served as the psychological foundation for this modernist art movement. The '85 New Wave movement is a collective art group that emerged in the mid-1980s with greater organization than the previous movement and was strongly influenced by philosophical thought, though it lacked unified ideas or artistic aims. It was, in fact, full of contradictions, so much so that fundamental questions such as what kind of humanism should be established were not agreed upon. The question of how a subject without subjectivity (reflexivity) could critically construct a subject with subjective content became an un-provable, cyclical question for 1980s art. The cultural solution provided by the Northern Art Group was half theological and half philosophical in nature: they strove to construct a Northern Temperate Zone Civilization that transcended geography and was marked by an extremely strong desire to supplant the Western civilization that they believed was entering its twilight. This concept was a bizarre assemblage of Hegel's philosophy of history and Nietzsche's philosophy of the superman (*Übermensch*). It opposed all purely formal modern art experiments, which they called "retinal games", and promoted the use of classical symbolist methods to construct their ideal visual world. The Southwestern Artists Group sought out their own conceptual resources from the philosophy of life and existentialism, and thus the body, transcendence, revelation and the flow of life were often themes of their work. These artists approached the various forces of reason with caution, and preferred painting styles like primitivism, expressionism and surrealism. The Tribe–Tribe (Wuhan), 0 Art Group (Changsha) and Red–Travels (Nanjing) groups of central China also revered mystic styles and religious experiences, but they tended to incorporate them into local practices. Unlike the modernist art schools mentioned above, the various artistic experiments which emerged in the south-eastern part of the country were more receptive to the linguistic phi-

losophy of Wittgenstein, Popper's philosophy of science, Heidegger's poetic philosophy and even certain postmodernist influences. Their art tended more towards the conceptual. The Pond Society out of Hangzhou was doubtful of philosophical reflection and social content. They preferred to focus on the individual's inner sensory observations and experiences which they considered indefinable and happy accidents, while artists such as Gu Wenda and Wu Shanzhuan instead viewed artistic experimentation as an unclassifiable game of language and writing. A more radical experiment emerged on a remote stretch of the coastline – Huang Yongping's Xiamen Dada group stemmed directly from the conceptual art of Marcel Duchamp. They met virtually all modernist art traditions – from systems to camps of style, from the aesthetic theories of expressionism to the concepts of innovation and progress – with thorough scepticism and criticism, which naturally led the "anti-art art" of the collective to a radically relativist school of Eastern thought: Zen.

The modern art movement of 1980s China remained confined by enlightenment thinking and idealism, while the 1990s enlightenment project of establishing subjectivity was met with a confrontational attitude. The conflicts that defined it would dramatically change the well-established axis of issues relevant to Chinese modern art, while affording the movement the opportunity to engage in an open dialogue with the problems of the outside world. The pressure brought by these challenges is related to the phenomenon known as globalization, and was the result of the expansion of the Western art system. Beginning with the 1989 French show *Magiciens de la Terre*, curated by Jean-Hubert Martin, the Western exhibition system began to incorporate enormous amounts of Chinese modern art; meanwhile, China's further reform and openness brought the nearly century-old Western art market system into the country, thus contributing to decisive change. These two phenomena fundamentally altered the existential climate and subjective worth of artistic activity. The construction of subjectivity formed from the principles of enlightenment, which was typical in the 1980s, was replaced by identity-formation strategies, while the great cultural question was split into various discussions of exacting linguistic solutions. The two themes of contemporary Chinese art in the 1990s (the modern art that was made after 1990 is usually called contemporary art), namely the relationship between conceptual art and linguistics, and the question of how to attain international status, were theoretical reactions to this oppressive reality.

In the late 1980s, as many Chinese artists left the country, contemporary Chinese art shifted towards openness. The names Gu Wenda, Huang Yongping, Xu Bing, Cai Guoqiang, Chen Zhen, Wu Shanxhuan, Zhu Jinshi, Wang Gongxin, Lin Tianmiao and Guan Wei were associated with a new way of experiencing the outside world, one that included both cultural clashes and fusion. Within China, though group-based, movement-oriented artistic activities had ceased, leading figures such as Wang Guangyi, Shu Qun, Zhang Peili, Geng Jianyi, Gu Dexin, Wang Luyan, Li Shan, Yu Youhan, Zhou Tiehai, Ding Yi, Mao Xuhui, Zhang Xiaogang and Ye Yongqing pursued their art in different directions, while younger artists such as Fang Lijun, Yue Minjun, Wang Jianwei, Sui Jianguo, Zhan Wang, Yin Xiuzhen, Song Dong, Yan Lei, Lin Yilin, Xu Tan, Chen Shaoxiong, Yang Fudong, Qiu Zhijie and Xu Zhen represented new artistic perspectives. Their new artistic visions, in turn, meant new difficulties: the shift in values between the old metaphoric and narrative systems and the present ones, the clash between systemization and anti-systemization and the linguistic conflict between

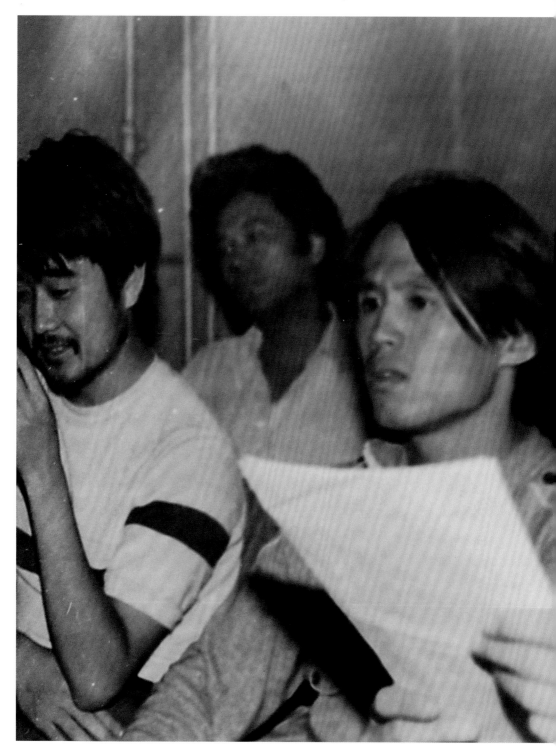

The Northern Art Group hosting a symposium
at the Heilongjiang Provincial Museum of Art,
Harbin, China, 1985. Front row, left to right:
Liu Yan, Shu Qun, Wang Guangyi

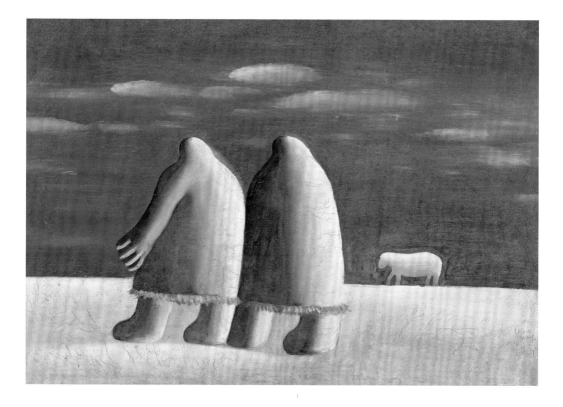

the modern aesthetic experience and conceptual anti-aesthetic experimentation. This led contemporary Chinese art to wander directionless; ideas about subjectivity were still a latent and fundamental problem, art was no longer rooted in the grand and illusory goals of the 1980s but was tied to the postmodern idea of subjective fragmentation that filled the art with negative dialectics. From these reflections, the effort towards the construction of subjectivity often turned its focus towards specific problems such as the maintenance of autonomy and the preservation of one's individuality amidst the colonial hegemony of Western contemporary art. These reflections were a situational reaction marked by deterministic qualities. From the slogans about cultural idealism of the early 1990s to the reflective criticisms of post-colonialism, the functionality of the market and the curatorial system in the mid- and late 1990s; from practices aimed at establishing local, independent public systems and art organizations to such anti-scholarly theoretical criticism solutions as "boundless realism" (Shen Yubing), these efforts to explore subjectivity were always in a state of tense coexistence with the various forms of cynicism, scepticism and Cold War mentalities. In artistic practice, the exploration of subjectivity unfolded within extremely individualistic principles and approaches, which often swayed between the unearthing of accidentally positive characteristics of subjectivity and an essentialist refusal of them. Contradictory and bipolar tendencies ensued with hidden, deep and rational currents, known by some critics as "little movements" (Liu Ding, Carol Yinghua Lu, Su Wei). Radical experiments were undergone that refuted the body under the rubric of performance art (often generalized as a certain politically resistant attitude), highlighting the paradoxical logic that, in the search for subjectivity, exists between individual experimentation and rational construction.

Wang Guangyi,
Frozen North Pole No. 24, 1985
Oil on canvas,
68 x 86 cm
(26¾ x 33⅞ in.)

Arguments pursuing the establishment and fragmentation of subjectivity have created two poles along the axis of modern Western thought and philosophy. Thinkers from Hegel, Marx and Weber to Nietzsche, Benjamin, Freud, Husserl, Heidegger, Lacan, Foucault, Derrida, Althusser, Habermas and Popper have historically depicted the complexity and dynamic nature of this axis. Modernity is an enormous consciousness-raising movement that constantly confirms and reflects upon man as a knowing subject. The cornerstone of this cognitive activity is art: all conceptual approaches to modernity make use of conceptual approaches to modern art, and from this perspective it is clear that art has never, and could never, be autonomous. Hegel's historical theory of absolute spirit bestowed art with the worth attributed to the phases of (spiritual) development, and from this many theories of the "end of art" followed, though this determinist logic was later challenged by both rational and anti-rational camps. Nietzsche replaced God, the incarnation of rationalism, with the nihilist artist, but art history devoid of subjectivity cannot bring about true liberation. To the contrary, it can only lead art into a state of extreme superficiality, and the artist/superman is reduced to a giant with feet of clay. Nietzsche's deconstruction of subjectivity was the basis of every form of anti-essentialism and accelerated the disintegration of the rational world. It was within the postmodern theoretical context that conceptual art gradually descended from a critical experimental force into an empty philosophical and linguistic game.

The modern and especially the postmodern are often portrayed as movements of disenfranchisement. This portrayal has diminished their complexity, rendering them clichés of modernity; as if the word "secularization" could ever fully define the world we inhabit. The enigma that is the world may be looked at from either a historical or contemporary perspective; it cannot be exhausted by the rationality/revelation, here/there and science/beliefs dichotomies. The relationship between politics and theology must be posited within this frame. Since Plato, traditional Western politics have been inseparable from theology; this Western political model was the secular version of God's theological model. Christian theodicy largely increased this mirroring, this mimesis, and raised it to a level of transcendence, placing it beyond the realm of history. The Enlightenment eventually dismissed this homogenous theodicy though it did not end the relationship between theology and politics. To the contrary, the historical drama of this relationship became restaged in more complex, strange and dialectical ways. It was characterized by the replacement of absolute theodicy with a relative theodicy in which the transcendental historical relationship between theology and politics was replaced by historical relevancy. The Kantian taxonomy of modern human knowledge is based both on genesis and crisis theory. Kant's thesis shattered the theologically harmonious world while retaining the *sukhavati* (the celestial realm or pure land), and thus it planted the seed for the tenuous relationship between the transcendental theological world and the empirical secular world. In this regard, reflections on politics and theology have always been central to modernity. For Nietzsche, the heretic Dionysus replaced the Christian God, and superman-politics seem to succeed in bridging the tremendous historical gap between the gods and men; Walter Benjamin's proposal on the salvation of the *Messiah* originated from his contemplation of the politics of industrial civilization in which philosophy of language, politics and theology are inseparably related; even Leo Strauss's ultra-conservative position on the interpretation of the relationship between theology and politics was not a mere renaissance of orthodox Judaism, but a response

by traditional theology to the danger of the present outlook on the relationship between theology and politics. Deconstructivist post-structuralism seemed to have shifted this historical balance. All theological discussions and histories of transcendentalism were being interpreted as linguistic strategy or political conspiracy; however, theoretical rhetoric still may not break free from theodicy. Thus, later on, Derrida would reinterpret Heidegger's existentialism: "so there may be life after deconstruction after all".[1]

In the modern era, the art world took on the eternal role of witness and mediator in the tenuous relationship between the theological and the political world. It established a "pure land" of imagination between the transcendental and experiential worlds (and this land may find legitimacy in Kant's judgement). The boundaries of this aesthetic world, this promised land, remain unstable; it remains a troubled enclave to which migrants might flee, where theologians, philosophers, scientists, politicians and even vulgar businessmen come to explore. In this land, artists strategize, negotiate and wage wars with invaders as they attempt to gain ground. Thus, contemporary art became the wrestling ground for issues on contemporary politics and theology, and a hub for establishing connections between these two fields. Perhaps, like Nietzsche claimed, "we possess art lest we perish of the truth".[2]

In establishing a subject-based historical context, political issues and theological issues have always been central concerns for contemporary Chinese artists. To an extent, these concerns have determined the varying values within contemporary Chinese art and contemporary Western art. Politics are mainly represented through the tension between capitalist systems and Western art values, but for Chinese artists the parameters of this tension may seem more complex. For them the politics/theology tension is paired with the control and containment conducted by the existing bureaucratic system, and the allure and corruption of the new capitalist market relations. Moreover, this tension is in constant struggle with the oppression of the dominant Cold War mentality that has been imported from the mainstream ideology of contemporary Western art. Ultimately, it is this thinking that has encouraged the Western art system, the media and curators to shape contemporary Chinese art into a simple tool of political resistance, extracting its rich and irreplaceable artistic and historical values. On the other hand, theological issues, namely the process of searching for the transcendental within art has never become a central issue due to the absence of religious traditions and the impact of Western deconstructivist movements on contemporary Chinese art. Historically, unlike the omnipresent Christianity, China did not establish a standard religion. A deeply rooted theological tradition was not absent, however, if we define theology more broadly as an exploration of the infinite transcendental world. Modern science and materialism have deeply segregated the Chinese from their own theological tradition, and the pursuit of the various postmodern ideologies has shattered an already fragile cultural confidence and depleted the human values established in the early modern movements of contemporary Chinese art in the 1980s. At present, contemporary Chinese art is undergoing a phase of unprecedented isolation with regard to ideas, values and systemic support. If one does not contemplate political and theological issues in a legitimate historical context, the "finality" of this history will be more than just a theoretical judgement.

An uncertain subject lacking a fundamental essence can only take form and be understood through a critical historical dimension and through rational

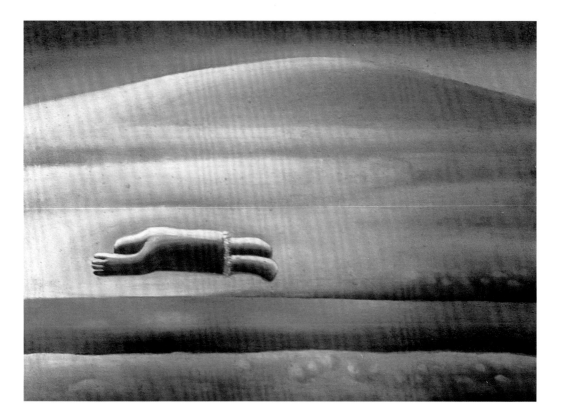

Wang Guangyi,
*Frozen North Pole
No. 33*, 1985
Oil on canvas,
63 x 88 cm
(24³/₄ x 34⁵/₈ in.)

reflection. This is most easily verified by Popper's theory of World 3. World 3 is the world of spirit and concepts, created by people through language and its physical forms (books, tools, various theoretical approaches and artworks), and once it is produced, it is autonomous and independent of the subjective World 2 and the objective World 1. Only through verification and the critical-theoretical reconstruction of World 3 is it possible to establish a new theoretical and conceptual world. Popper's theory merges a non-rationalist approach that negates the integrity of the subject with the opposing subjective rationalist approach. Both are placed on a methodological scale of critical rationalism. The result is a subjectivity whose essence cannot be taught, but is founded on rationality. World 3 does not have to do with Descartes's "I think therefore I am", nor with the "end of man" found in the later, more radical canon. Instead, it is a boundless space of exploration and rational comparison, of reflection and constant openness. The nearly thirty years of contemporary Chinese art history have already produced an open, objective and unique World 3. Contemporary Chinese art is now faced with the subjective problem of how to critically and reflexively describe this visual process. Given these circumstances it is only natural that the theoretical issue of constructing subjectivity evolves into a more specific historical problem of how to begin constructing its own art history.

Some friends of mine who are Western scholars have asked me why, in researching contemporary Chinese art, I mainly use Western philosophy, ideas and art history methods and approaches, and why I have not attempted to use traditional Chinese ideas and theoretical methods to establish a theoretical model that uses China's own thinking to explain its own art. My response is that first,

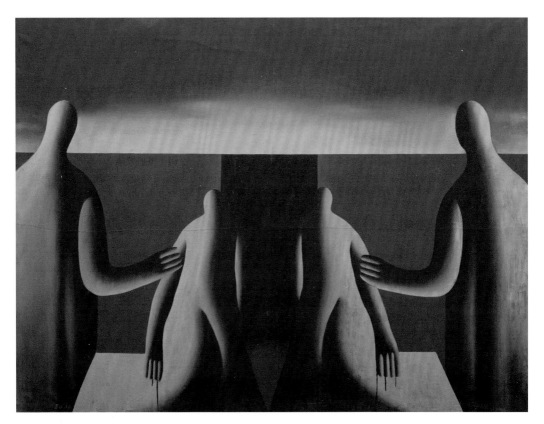

Wang Guangyi,
*Post-Classical:
Simultaneous
Annunciation*, 1986
Oil on canvas,
160 x 200 cm
(63 x 78³/₄ in.)
Collection of Wang
Luyan, Beijing, China

Wang Guangyi,
*Post-Classical: Gospel
of Matthew*, 1986
Oil on canvas,
100 x 100 cm
(39³/₈ x 39³/₈ in.)
Collection of Sun
Yujing, Chengdu, China

pp. 34–35
Wang Guangyi,
*Three Sections of
Human Body*, 1987
Oil on canvas,
86 x 68 cm
(33⁷/₈ x 26³/₄ in.)
Yuz Foundation,
Hong Kong, Jakarta,
Shanghai

Wang Guangyi,
*Three Sections of
Human Body*, 1987
Oil on canvas,
86 x 68 cm
(33⁷/₈ x 26³/₄ in.)
Fondation Guy &
Myriam Ullens,
Geneva, Switzerland

modernity and modern art are, after all, Western cultural phenomena, and contemporary Chinese art is the product of the direct influence of contemporary Western art. Only by understanding its conceptual and artistic sources can we engage in an academic evaluation of contemporary Chinese art's unique traits and potential development. Second, ancient Chinese thinking truly does have the potential for transformation into a modern or even contemporary approach to thought, but this is an arduous process. Many Chinese intellectuals in modern times have expended great effort to this end, but this transformation, whether in terms of depth or breadth, is still far from replacing the modern Western models and methods for explaining the progression of contemporary Chinese art. In fact, aside from certain conservative thinking models such as New Confucianism, I have yet to discover a local source of ideas that has the potential to truly resolve China's modernization issue. If we are satisfied using simple Chinese concepts and methods to explain the phenomenon of contemporary Chinese art, though we may gain a modicum of political correctness, the actual effect of such an approach would perhaps be Procrustean and counterproductive. This is completely different from the use of ancient Eastern concepts by Chinese and Western artists to engage in contemporary artistic creation. It took three hundred years for Buddhism to spread into China and become Chinese, and we only truly began to come into contact with modern Western thought a century ago, though the process was suspended by the Cultural Revolution. I hope it does not take as long for modern Western thought and traditional Chinese thought to fuse together to forge a contemporary Chinese system of thought. Third, I wish to reject the historical paradigm wherein China first clashes with the West and then gives its response. The modernization of Chinese art and the modernization of Chinese society were both rooted in the internal issues and logic of Chinese culture. Even certain artistic styles and movements that appear to be the same are rooted in vastly different contexts and conceptual logics. In analysing how modern Chinese art came to accept classical, modern and contemporary art traditions from the West, I prefer a microscopic historical approach that observes their different contexts, different revision principles and their different historical effects. For instance, in researching the art of Wang Guangyi, I am very interested in his corrections and appropriations of Western classical painting and Pop Art. Overall, I find the historical exploration of specific artistic issues and approaches more attractive than the erection of some local theoretical framework for interpretation.

The case of Wang Guangyi that will be investigated in this book is the product of the theoretical and practical context described above. As an artist, Wang Guangyi was a leader of the Northern Art Group, China's earliest modern art group. The artistic vocabulary he has employed includes realism, classical symbolism, Pop and various forms of conceptualism. As a thinker, he has always drifted between the empirical and transcendental worlds, and between politics and theology to deal with the questions he has asked himself. As a figure who experienced and influenced the three whole decades of contemporary Chinese art history, he is clearly a key protagonist in the story of the current state of art. The goal of my research is not only to present the complex artistic questions and various solutions that have marked the different phases of his career, but more importantly, to place his individual story within the general historical movement of the construction of subjectivity within contemporary Chinese art in order to better investigate his work as an artist, stressing the openness and complexity of the historical process of which he is an important part.

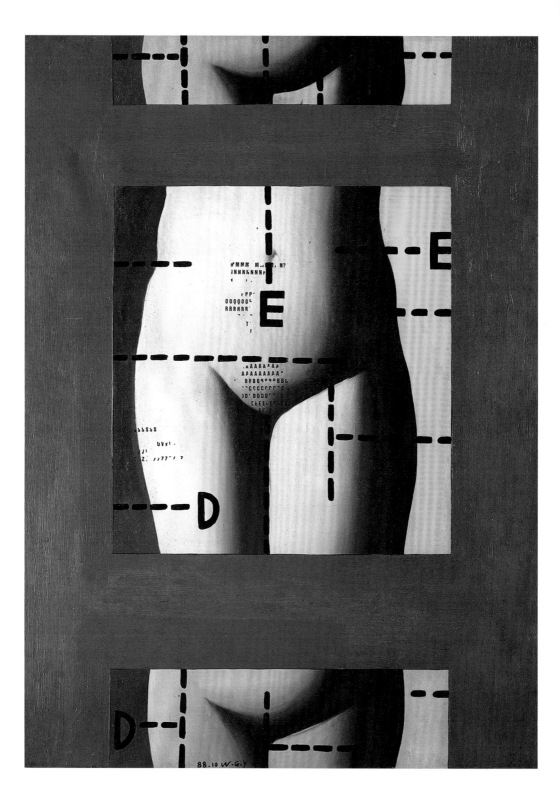

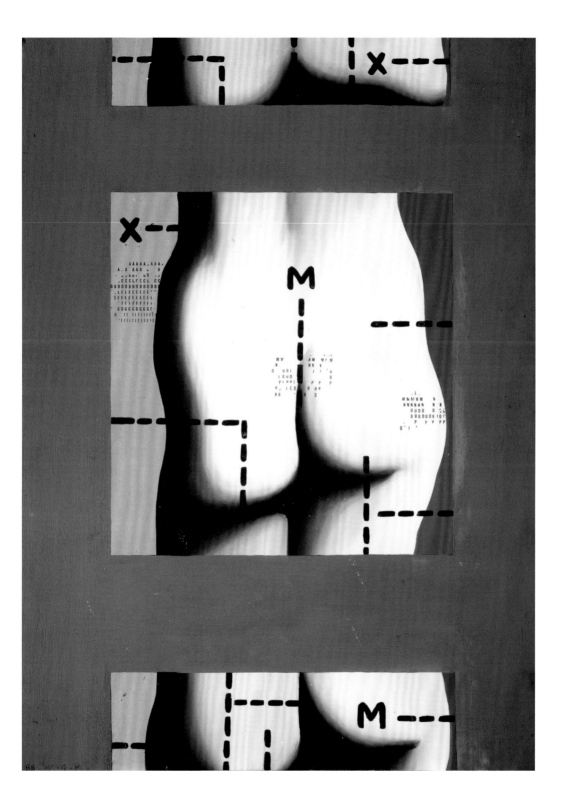

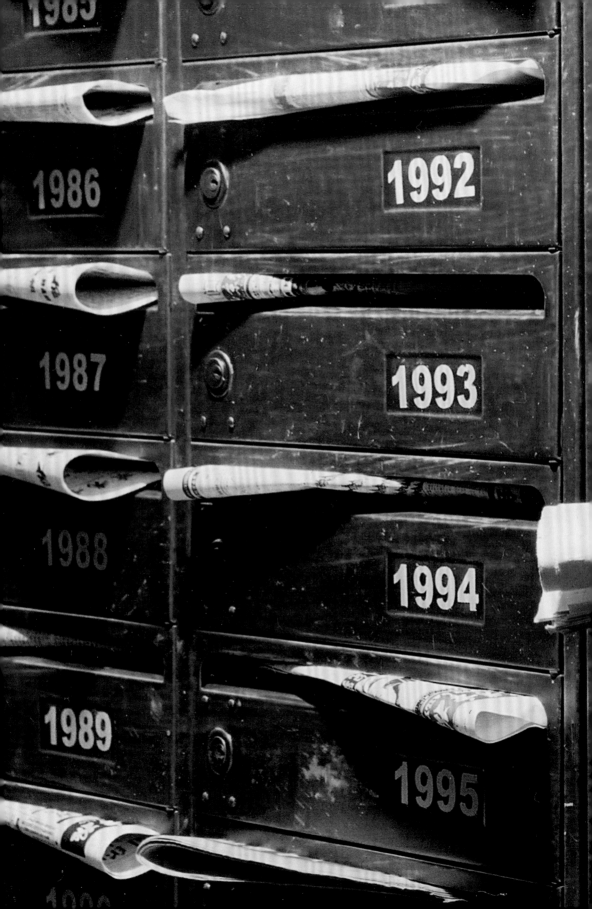

Wang Guangyi,
*The History of a
Newspaper*, 2002,
detail
Metal mailboxes,
newspapers, printed
materials, 3 pieces,
67 x 104 x 21 cm
(26³/₈ x 41 x 8¹/₄ in.)
each
Exhibited at *Media and
the Arts*, World Trade
Center Exhibition Hall,
Beijing, China, 2002
Beijing Youth Daily
Collection, Beijing, China
Courtesy of Beijing
Youth Daily
Photo Cui Jun

Politics in Art

Wang Guangyi does not care about the art of politics, only about the politics of art. He has always held a special position in contemporary Chinese art, one that is comprised of the contradictory elements typical of his art. Though the *Great Criticism* cycle will never again prove so visually shocking, we cannot deny that the images within it – more accurately, his handling of the images – precisely re-count all of the contradictory experiences we lived at the time: from destructive anger to a deviation from faith, from the bravery of heroism to the leniency to-wards consumerism, from grave criticism of international politics to national catharsis. The artist creates one visual enigma on top of the next while simulta-neously erasing his tracks before the spectator can comprehend the sense of his work. Within art history, he remains a powerful yet unfathomable artist.

The Misread *Great Criticism*

Everyone – critics, mass media, art historians and the market alike – has always considered Wang Guangyi the poster boy for Chinese Pop Art. This definition can be traced back to the *First Guangzhou Biennial* held in 1992. Within the oil paint-ings section, the *Great Criticism* series won the Document Award, the greatest academic acknowledgement by Chinese art critics. The award comments read:

> In *Great Criticism*, familiar historical forms have been deftly linked to what were once irreconcilable popular contemporary icons, sending a hopelessly tangled meta-physical problem into suspension. With the language of Pop Art, the artist has named a contemporary problem: so-called history is a linguistic prompt tied to contemporary life; *Great Criticism* is one of the best examples of such a linguis-tic prompt to come out of the early 1990s.[3]

While this was a somewhat incomplete appraisal, the *After '89 New Chinese Art* exhibition held in Hong Kong the next year unequivocally bestowed *Great Criti-cism* with the title of Political Pop. Li Xianting, who coined the phrase Political Pop, describes it thus: "Since 1989, many important artists of the '85 New Wave successively did away with their metaphysical applications, and without con-sulting each other, began orienting themselves towards Pop; most of them were dedicated to deconstructing the most influential subjects and political events in China in satiric ways". According to Li Xianting, for the Chinese deconstruction-ist culture of the time, Political Pop was identical to Cynical Realism, except that the former found its inspiration in "reality within the broader social and cultural frame" and the latter "more from an experience of the real that pertained more to the self and its immediate surroundings".[4] Wang Guangyi's *Mao Zedong* (1989) and *Great Criticism* (1990) cycles began to be seen as the representative works for this style of painting and since then, discussions of them have always been

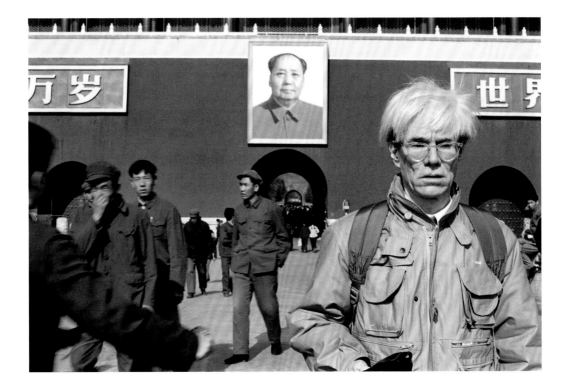

circumscribed by this reading. In 1992, the authoritative Western art magazines *Flash Art* and *Art News* gave ample coverage of *Great Criticism*, which allowed Guangyi to participate in the *Cocart International Art Invitational* held in Italy and the 45th Venice Biennale. Ever since, *Great Criticism*'s Political Pop not only became the main route through which Westerners came to know contemporary Chinese art, it also became, for critics, the main reference through which to judge the success or failure of Wang Guangyi's later projects. Critics felt that "this artwork, in terms of art, is just a copy of little value", which affirms that "as China passes its political peak and moves towards its economic one, the creative impetuosity of artists is the epidemic of the period in which our history transforms into a commercial society".[5] Another criticism was that Political Pop indulged America's Cold War strategic need to suppress China.[6] *Great Criticism* became famous because of its classification as Political Pop, but it inevitably paid the price of such fame: a misreading of its practices based on old methodology.

One could venture that this classification by critics of *Great Criticism* mostly results from the habit of extracting Wang Guangyi from the developmental logic of his own personal art history, as well as from the context of modern Chinese art. In an article about the birth, characteristics and development of Chinese Pop Art I proposed that:

> The Pop art that arose in post-war America had two distinct backgrounds, one in cultural history and one in art history. The first refers to the nourishment it garnered from the mass-popularization and utilitarian aesthetic tradition of American culture, and was a physical reaction to the fragmented, superficial, trivial consumer culture that emerged after the Second World War. The second established the rejection of the elitist styles of modernism such as Abstract Expressionism. Warhol's visit to Chi-

na in the early 1980s, and most importantly Robert Rauschenberg's solo exhibitions in Beijing and Lhasa in 1985 initiated the spread of American Pop ideas. This moment just happened to arrive at the peak of China's '85 New Wave art movement, which was marked by the ideals of enlightenment culture and rebellion. It was this set of circumstances that produced such a bizarre depletion of meaning: Pop was very roughly taken to be a kind of subversive Dadaism, and its deconstructionist underpinnings were only superficially understood. For political reasons, in the early 1990s Chinese society quickly completed its transformation from an enlightened culture to a consumer culture, and Chinese artists, still dramatically disturbed by the failure of cultural enlightenment ideals, suddenly realized that they were immersed in a completely unfamiliar economic system. The loss of ideals and critical identity left them at the mercy of chaos, suspended between the constructive enlightenment of modernism and the opposing postmodern tendencies: all of this led to Pop's being embraced as the natural stylistic choice of the time. This choice was based on a clear misunderstanding of Pop, which was seen and used as a critical instrument and deconstructive tool. … Early Chinese Pop Art contained clear differences with respect to Western Pop. First and foremost, the appropriation of ready-mades was historicized and definitely not limited to that which was "current". This differed markedly from the "random" or "neutral" image selection method used in the West. Secondly, the linguistic strategy of removing meaning was replaced by an attitude of rearranging meaning that derived from the above-mentioned method of appropriation. This established the most unique, bizarre and contradictory semantic and cultural traits of Chinese Pop Art, which deconstructed the original images by constructing new meanings, and removed cultural significance through its critical attitude towards culture. Wang Guangyi's *Great Criticism* forces images from China's political history to interact with the diametrically opposed images of Western consumerism, and this is why it produces a new and effective form of critical power.[7]

Without keeping in mind the dual nature of Chinese Pop Art and only seeing it as a direct product of Western modernism, it would be difficult to make reasonable judgements about its logical relationships to the cultural enlightenment and social criticism of the 1980s. Also, an evaluation of *Great Criticism* should place Wang Guangyi's artistic methods within his conception of history, so as to draw a rational interpretive conclusion.

For a time in the early 1980s, Wang Guangyi was a utopian; he believed that a healthy, rational and strong civilization would be sufficient to save a culture that had lost its beliefs. His early artistic activities with the Northern Art Group and his early series *Frozen North Pole* displayed a passionate and illusory pursuit of culture. The idealized style, imbued with civilizing intention and marked by its coldness and succinctness did not last long. In his *Post-Classical* series, which he began in 1987, the artist opted for highly analytic depictions. He set aside sentimentality and began revising the manuscript of history to complete his work of cultural criticism. If in *Black Rationality* and *Red Rationality* the subject of analysis was still limited to classical art and literary classics, then it is with *Mao Zedong: AO* that he first began using political iconography as material for analysis. Perhaps we should deemphasize the term "analysis", because the marks and letters placed on top of the leader's image are not the consequence of analytical analysis nor do they indicate any political position or attitude. They have only one function, and that is to break from the established semantic expectation and aesthetic judgements that this iconography evokes in the observer.

In 1989, Wang Guangyi classified the pictorial theories and methods that were produced during this period as a "clearing out of humanist passions"; this

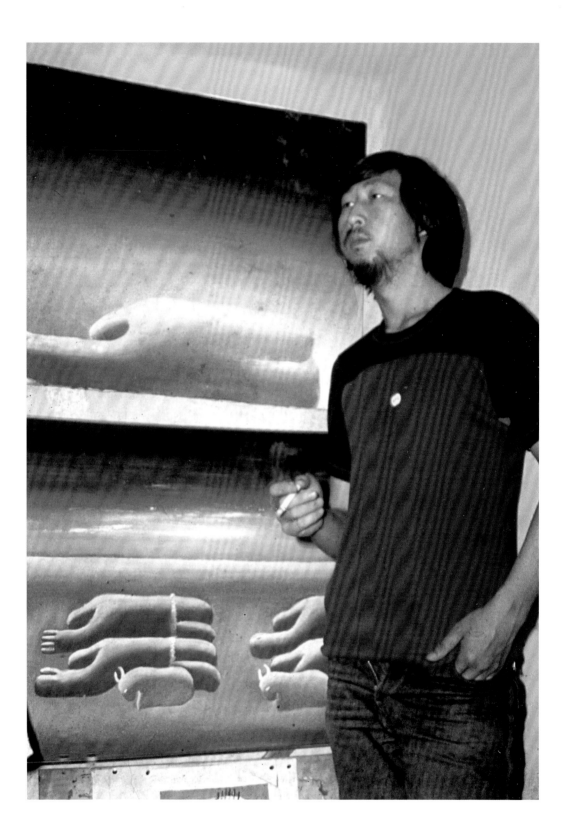

may be understood as a desire to maintain tension between the empty (idealized) abstraction of humanist passions and a cold, critical rationalism. It should be pointed out that during this period, in which he used classical art, literary classics and political images, his work was mainly directed at the semantic lack produced by the reigning humanist passions of the '85 New Wave; it was not a political stance, and though he made use of ready-made images his work was wholly unrelated to the Pop strategy of deconstructing an image's meaning. Wang Guangyi explained his decision to use political images such as that of Mao Zedong by saying:

> I had wanted to provide a basic method for clearing out humanist passions through the creation of *Mao Zedong*, but when *Mao Zedong* was shown at the *China Avant-Garde Exhibition*, observers multiplied the humanist passions by a hundredfold to imbue *Mao Zedong* with even more sentimental value. ... *Mao Zedong* touched on the question of politics. Though I was avoiding this question at the time, it really touched on it. But I wanted to use an artistic method to resolve it; a neutral attitude is a step better than an artistic method.[8]

What is important here is the way the artist proposes a neutral attitude because we can see this neutrality towards politics and ideology in his later works. This neutral attitude is not detachment; instead it indicates that art can only make effective judgements about political events and history after it has removed specific political standpoints and all emotional involvement (humanist passions), this way it can naturally present the inherent significance and value of the work. These are the cornerstones of Wang Guangyi's visual politics, which have their roots in his understanding of classical and contemporary art, and are necessary to fully comprehend his political nature.

The *Post-Classical* series represented an important stage in Wang Guangyi's transition from modernist to contemporary ideas. In this period he clearly divided classical and contemporary art, ascribing to the former both the art of the classical period and modern art: "They draw their meaning from the general structure of classical knowledge, they are the natural product of a projection of humanist passions". What they express are mainly mythological illusions, religious zeal and the common and mundane emotions of the individual; contemporary art instead has discarded its dependence on humanist passions and its quest for the meaning of art; it "attempts to resolve the problems of art and establishes a logically verifiable linguistic foundation which uses past cultural events as empirical material".[9]

Of course, what really brought about Wang Guangyi's transition from modern to contemporary artist and his recognition within art history was his 1990 *Great Criticism* cycle. With this cycle he finally found a method of portrayal that both used "past cultural events as empirical material" and was "logically verifiable". With *Great Criticism* he also put an end to the tension embedded in creating a complete and coherent artistic style, placing two diametrically opposed images – propaganda posters of the Cultural Revolution and Western consumer advertisements – within the same space. This method seems like stylistic gamble, as it uses this contradiction to narrate the empty state that culture faced in the bizarre landscape where the enlightenment era was replaced by the consumer era. If we consider the politics of *Mao Zedong* nothing more than a choice of pictorial style, then it is with *Great Criticism* that the politics truly become the empirical material to be subjected to logical verification. But *Great Criticism* cannot be limited by reality, events,

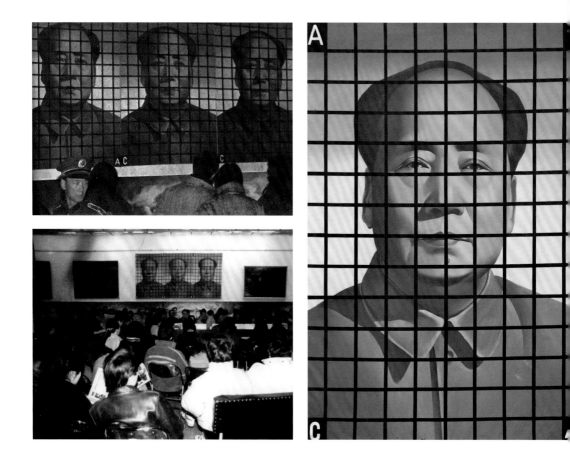

Views of the *China Avant-Garde Exhibition* at the National Art Museum of China, Beijing, 1989
Photo Wang Youshen

or political authority in the strictest sense – Political Pop in the original sense would be – because the use of images from the materialist age and signs from consumer culture does not create a finalizing judgement of either, but establishes a theoretical relationship between the two that may lead to multiple interpretations. To put it simply, if *Great Criticism* deconstructed or criticized something, then it was merely the use of humanist passions to conceive of politics; if it created something, perhaps it created a neutral method of portrayal, a method capable of continuously attracting attention and analysis. The artist is often pleased by this:

> I think the reason that people remember *Great Criticism* – even if they don't like it – might be explained by the term "non-point of view". I didn't always know this phrase: it can be defined as a neutral perspective. Everyone thought I was criticizing something, that I had a clear standpoint, but they slowly realized that I had not declared anything. Perhaps *Great Criticism* drew its meaning from all of these serendipitous reasons. Later I happened to converse with a philosopher, and he said that in philosophy this attitude was called the "non-point of view".[10]

The "non-point of view" does not indicate a lack of position but a repudiation of set modes of thought and biases, in favour of a neutral relationship with the object so that the potential of the art becomes more varied and open. Zhao Tingyang, the philosopher friend to whom Wang Guangyi refers, describes the "non-point of view" thus:

42

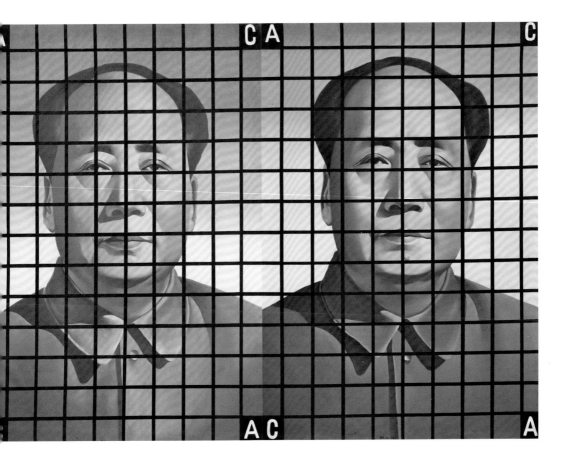

Wang Guangyi,
Mao Zedong: AO
(triptych), 1988
Oil on canvas,
150 x 360 cm
(59 x 141³/₄ in.)

The use of the non-point of view is the equivalent of giving every standpoint its useful place; in this way different standpoints are used in different contexts, and no standpoint is denied. That is to say, the neutrality merely strips away the absolute values or prioritizing of any viewpoint. … Above all it eliminates prejudice; only when biases are eliminated and prevented from becoming the basis of evidence can we see, listen to, and understand others.[11]

Turning to art critic Yan Shandui's psychoanalytic reading of *Great Criticism* we can understand that:

Wang Guangyi ingeniously grasped the tension between Warhol's spontaneity and Beuys's hermeticism. I think that this kind of artistic awareness is most suited to his personality: he unites Warhol's joyous acceptance, which is agile and adaptive like a monkey, with Beuys's cruel criticism, which is fierce like a tiger. To place these mutually contradictory images together is just the kind of humour that the artist has created for contemporary art.[12]

Another art critic, following the same line of thought, proposed that the works from this period manifested "the idea of bringing the revisionism of Gombrich together with Derrida's deconstructionism".[13]

These are all logical considerations to keep in mind when analysing Wang Guangyi's visual politics.

A Dangerous Premonition

In March 1989, having returned to Zhujiang after taking part in the *China Avant-Garde Exhibition* in Beijing that February, Wang Guangyi was not consumed by the excitement of the exhibition's success; instead he immediately began work on his first installation piece, *Inflammable and Explosive*. The materials for this piece are extremely simple: they are objects that resemble gunpowder bags with random letters on them, which may lead to associations with his *Post-Classical* works. Later on, I jokingly said that it was a true piece of "poor art", because it perfectly mirrored the artist's modest living conditions.

Though the critics had different explanations for this artwork, they all viewed it as a turning point. Yan Shandui believed that it was a "relatively rough mutation of Beuys' art", comparable to Picasso's turning point with his *Portrait of Gertrude Stein* (1906) and *Les Demoiselles d'Avignon* (1907).[14]

Lü Peng gave the following reading of the work:

> It brings to mind the "clearing out of humanist passions" that the artist recently spoke of. … The theme he engaged with is the way our latent drives (which include highly complex spiritual and extremely personal content) can be effectively controlled, so that the appearance of signs is not laden with clearly intelligible meanings imposed on it by the public. Unlike some of the previous series, *Inflammable and Explosive* does not seem to reference any representations from within art or cultural history, which has made it harder to interpret. Perhaps it is a particular sensitivity the artist has towards the future, but the implications of the work became quite easy to assess half a year later [this is a reference to the Tiananmen Square incident]. This series was started in March 1989, and the chaos, restlessness, instability, and discomfort taking place from the second half of 1988 to early 1989 was of no import; *Inflammable and Explosive* was perplexing and hard to explain. It was an enigma and it crumbled right at the point where its meaning began. That is to say that in entering the real world the artist simultaneously dissolved its problems. So from the beginning, people could feel that the traces of Pop have faded. It was a change in reality that provided a new context for evaluating the work. Circumstances changed and *Inflammable and Explosive* assumed a position that redefined its original meaning, made it explicit, and let the symbolic meaning of the work emerge.[15]

Maybe only people who actually experienced that period in history can understand the nature, extent and indescribability of the crisis that characterized it. It was an all-encompassing, yet specific crisis that hit every aspect of the country's reality: the culture, economy, politics, society, psychology and belief system. These might have been the circumstances that led to the creation of *Inflammable and Explosive*, but it is quite apparent that the artist did not intend to express this historic instability or directly express a political opinion. What he applied to this crisis seems to have been a kind of analytical stance: placing a logic within his artistic practice that "dissolved the problems of reality as he entered into it". In the solemnity of this political context we can see a reference to Beuys's misanthropy, and in the neutrality towards these topics we can find Warhol's cynicism. The artist deals with the crisis by presenting it as a premonition, as in *Inflammable and Explosive*, which is not charged with any realistic meaning: the refusal to offer the viewers specific readings or linear interpretations allows them to approach the crisis and its meaning in a more cogent and comprehensive way.

If, as it has been said, the work has a transitional worth, it is because it allows for a full understanding of the Pop methods used in *Great Criticism* (created the following year) and the actual motivations behind it, and more importantly it allows us to better evaluate the methodological worth of the more political themes the artist would tackle on throughout the 1990s.

An Analysis of the System

1990 was a watershed year for Wang Guangyi's art. The artist moved to Wuhan, began working not only on *Great Criticism*, which would win him acclaim, but also on two famous installations, *China Thermometer* and *Comparison between Chinese and American Temperature*. In a sense, it was these two works that truly brought Wang Guangyi's art in line with current political thought, because it is here that real and historic political iconography begins to be supplanted by specific ideological themes related to reality, that will then become the focus of his visual analysis.

According to Louis Althusser, ideology is the set of imaginary relationships that controls our reality and is embodied by a system of state-controlled illusory beliefs (religion, mores, rights, politics, aesthetics, etc.). Marx considered this set of relationships to be a product of the alienation process. He maintained

45

46

Wang Guangyi,
Great Criticism: R,
1990
Oil on canvas,
100 x 100 cm
(39³/₈ x 39³/₈ in.)

Wang Guangyi,
Great Criticism:
J. L. David, 1990
Oil on canvas,
100 x 100 cm
(39³/₈ x 39³/₈ in.)

left
Wang Guangyi,
Great Criticism:
Rembrandt Criticized,
1990
Oil on canvas,
300 x 200 cm
(118¹/₈ x 78³/₄ in.)
Collection of Zhang
Rui, Beijing, China

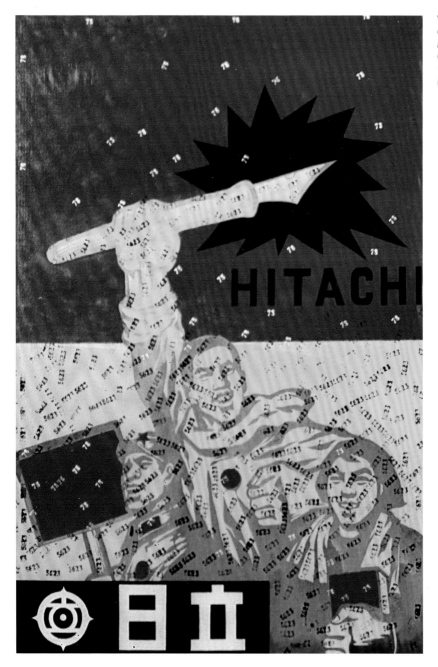

Wang Guangyi,
*Great Criticism:
Hitachi*, 1990
Oil on canvas,
150 x 100 cm
(59 x 39³/₈ in.)

Wang Guangyi,
*Great Criticism:
Maxwell House Coffee*,
1990
Oil on canvas,
150 x 100 cm
(59 x 39³/₈ in.)
Ludwig Forum für
Internationale Kunst,
Aachen, Germany
Photo Anne Gold

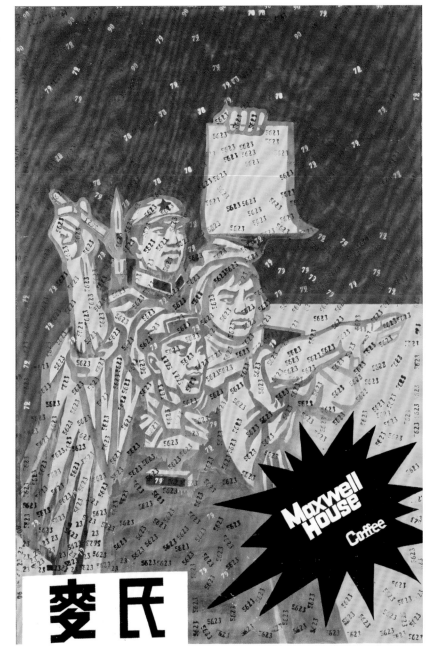

Partial view of the exhibition *Visual Polity: Another Wang Guangyi*, OCT Contemporary Art Terminal, He Xiangning Art Museum, Shenzhen, China, 2008

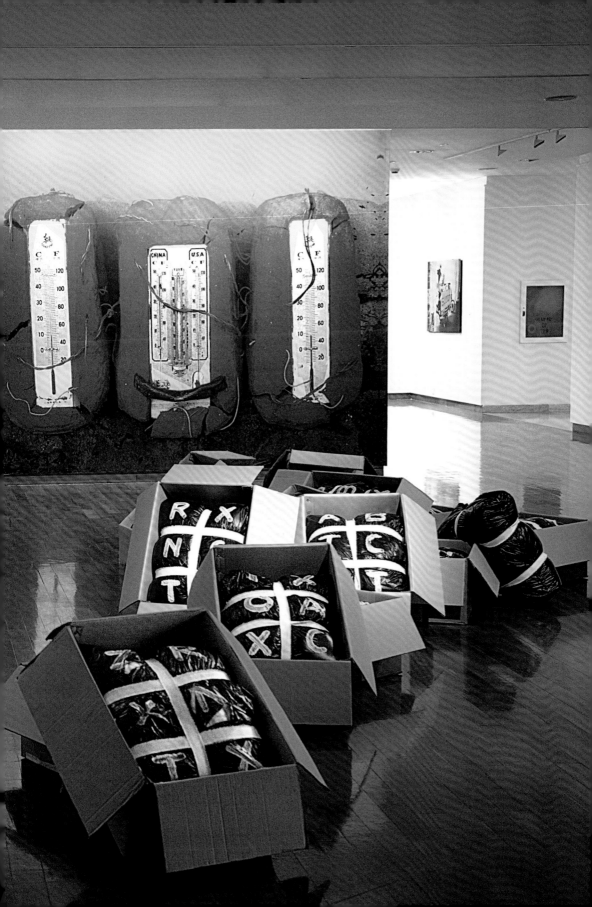

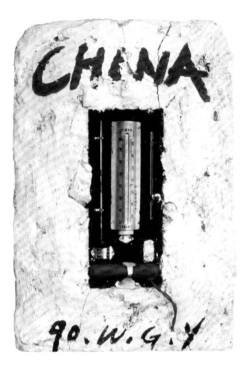

Wang Guangyi,
*Comparison between
Chinese and American
Temperature*, 1990
Thermometers, plaster,
electric wires, 5 pieces,
80 x 38 x 20 cm
(31¹/₂ x 15 x 7⁷/₈ in.)
each
Work destroyed

Wang Guangyi,
Zhuhai, 1989
Photo Liu Jinzhi

pp. 54–58
Wang Guangyi,
studies for *International
Politics*, 1993
Ink and felt-tip pen
on photocopy,
26 x 18 cm
(10¹/₄ x 7¹/₈ in.)
30 x 21 cm
(11³/₄ x 8¹/₄ in.)
30 x 21 cm
(11³/₄ x 8¹/₄ in.)
30 x 21 cm
(11³/₄ x 8¹/₄ in.)
26 x 20 cm
(10¹/₄ x 7⁷/₈ in.)
Collection of the artist,
Beijing, China

that alienation from humanity – from the self, the product, the society – caused people to form a "modified" (imaginary) reflection of their environment, which Engels called the "false consciousness". What interests Althusser about ideology is the process through which the system and the state apparatus exert control over people, or in his words, its "material practice". To investigate this phenomenon he thought it necessary to eliminate every moral perspective, and refrain from assessing the truth or falsity of ideas, concepts and beliefs. Instead we must dedicate ourselves to a symptomatic reading of the object of inquiry, such as an ideology, and thus distinguish the shadows and voice of the one controlling the ideology from "that which may not be spoken" and "that which cannot be spoken", the ambiguity and the omissions. Wang Guangyi's work in this period responds in every way to the features of this symptomatic reading.

"Temperature" is a neutral term with multiple meanings. Wang Guangyi once joked that perhaps it was the heat of Wuhan that inspired him to produce *China Thermometer* and *Comparison between Chinese and American Temperature*. If that were truly the case, then the word "temperature" would have nothing to do with meteorology. In fact, temperature and climate often take on political meanings, such as with the Spring of Reform or the Cold War, and it is just this kind of ideological discourse that constructs our imaginary, and often leads us to consciously or unconsciously ignore or not reflect on the complex and ruthless mechanism of control behind it. Perhaps the use of "temperature" in these two works is meant to suggest an obvious realization: temperature often serves a function in political narratives. We can see these works as a moderate transition from *Inflammable and Explosive* towards a concrete observation about the ideological system. Evidently, the problems they raise and methods they use are identical to those of *Great Criticism*. These two works do not lend themselves to widespread dissemination of symbols and multifaceted interpretation as was the

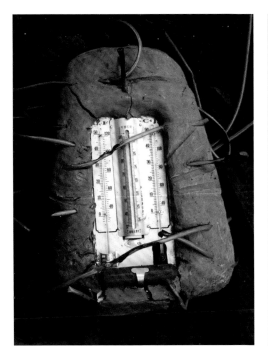
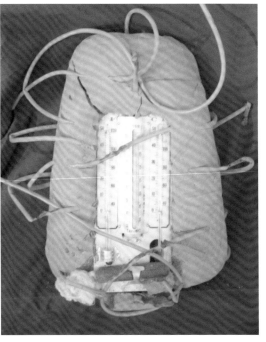

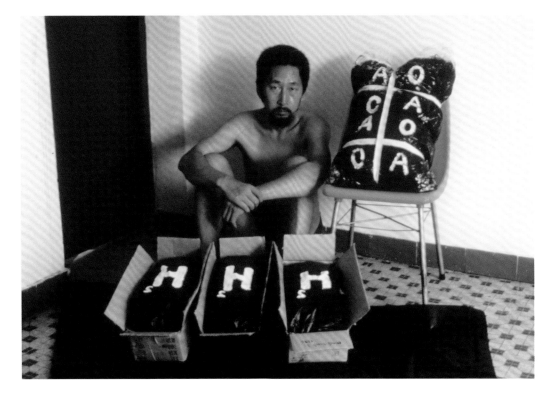

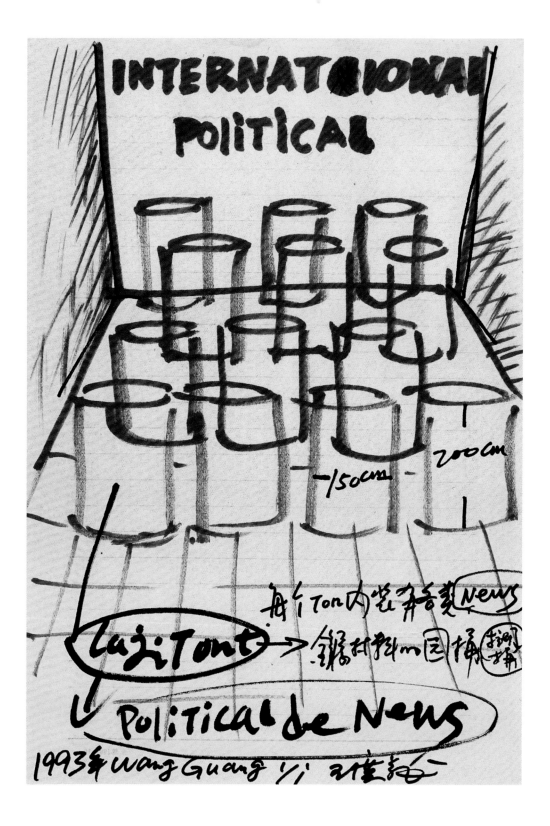

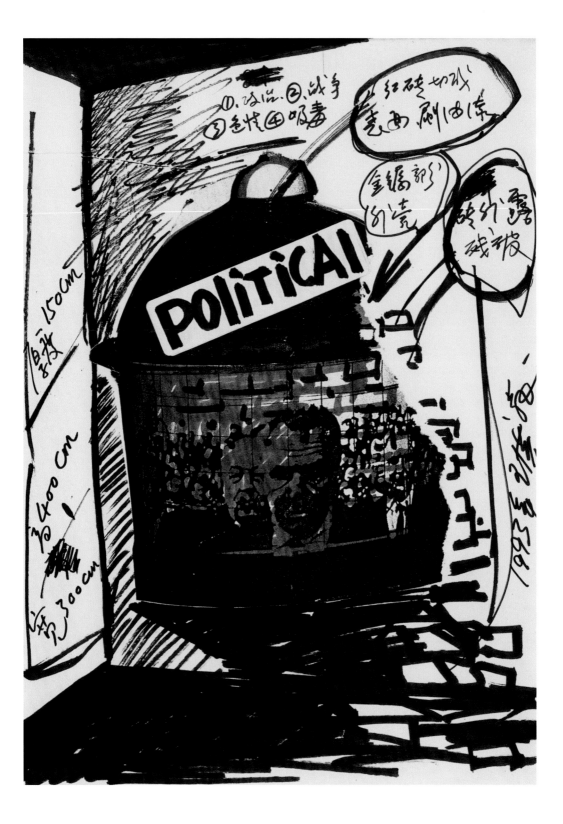

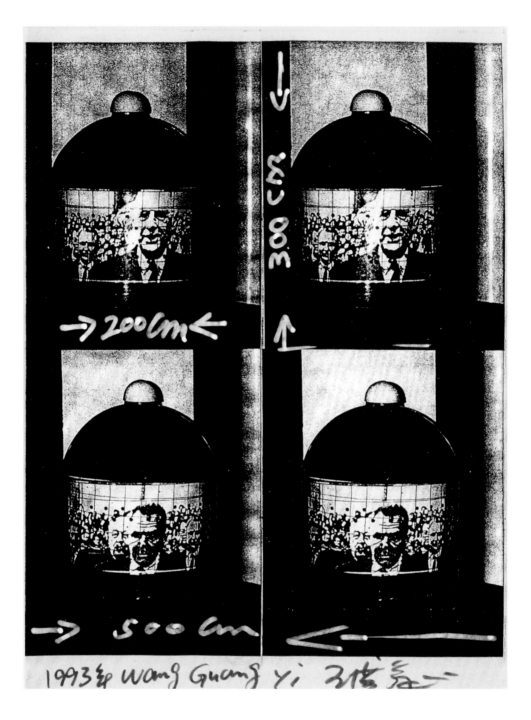

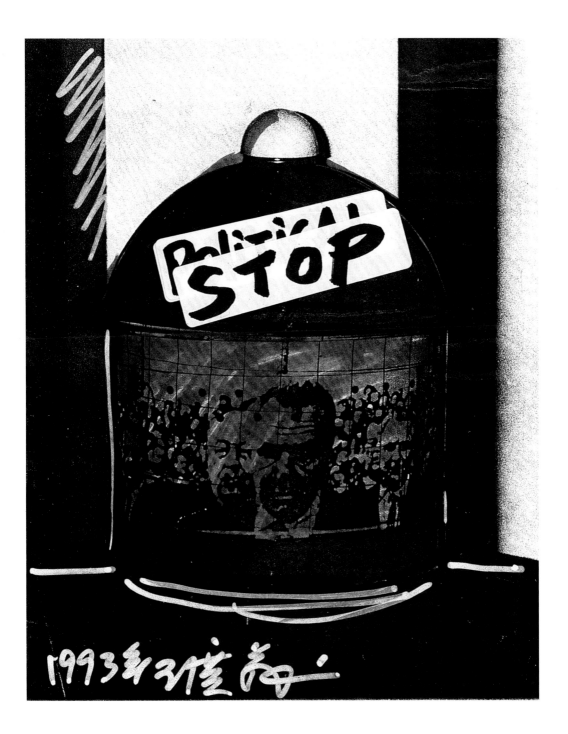

case with *Great Criticism*, which used recognizable political and consumer iconography, but they avoid unnecessary misreading.

After 1993, Wang Guangyi successively created works that referenced international politics, including *Eastern European Landscape*, *Visa*, *Drugs*, *Blood Test*, *The Similarities and Differences of Food Guarantees Under Two Political Systems*, *Origin of the Species – The History of European Civilization* and *Basic Education*. In these installations, the artist transferred the sense of crisis from *Inflammable and Explosive* into the realms of international politics, psychology and sociology (during this time he also created the cycle *International Politics*, a series of canvas pieces with the same theme, including: *Necessary Handshake*, *Necessary Ceremony*, *Necessary Meeting* and *Entry Visa*). There was a very clear motivation behind these works. After the 45th Venice Biennale, Chinese artists had the opportunity to compete with international contemporary artists on the same stage. While most Chinese artists at home and abroad focused on using traditional iconography to affirm their cultural identity and familiarize themselves with the rules of the international art system, Wang Guangyi instead observed the ideological systems of international politics. He described his work in this period as a "transformation of internal problems into external ones". We can read this definition in two distinct ways: on the one hand, Guangyi wanted to extend artistic questions to the social and political realms, and on the other to extend domestic problems to include international perspectives.

He raised this issue in his statement about *Visa*:

> *Visa* comes from the national image that is present at the visa offices of each country's embassy. In this sense, the visa places everyone in the shadows of the power dynamics between states. Here, everyone becomes the investigated. Perhaps in contemporary civilization and society, among all of the documents one fills out in one's life, the visa is the most ideological in nature. Everything that is shaped by ideology – man's emotions, beliefs and national identity – is embodied by the visa.[16]

In the visa process, which we are all accustomed to and accept as normal, Wang Guangyi has seen the shadows of the investigators of state power. Similarly, in *Blood Test*, the test is represented as the "investigative report on an individual life" performed by the national medical system; *The Similarities and Differences of Food Guarantees Under Two Political Systems* embodies the power of control exercised over people's lives by the food management system; in *Basic Education* the artist reveals the terrible logic within the war preparedness education programmes enacted in countries on both sides of the Cold War. Each of these works results from a symptomatic reading of the ideological text and what it lacks. In 1995, I gave the following reading of these works:

> *Visa* and *Eastern European Landscape* touch on international themes, and deal with the state of cultural politics as they have to do with the dissemination of ideology, the fight against marginalization, post-colonial culture and alternative culture on a global scale. Wang Guangyi is probably aware of the fact that defining his previous work as Political Pop would doubtlessly cause a crisis of value judgements: it would mean placing all contemporary Chinese art experimentation into the narrow confines of "Chinese discourse" or at best of "Eastern discourse" within a Cold War climate. This would mean suffocating the most stimulating part of contemporary Chinese art – the one that transforms Chinese problems into glob-

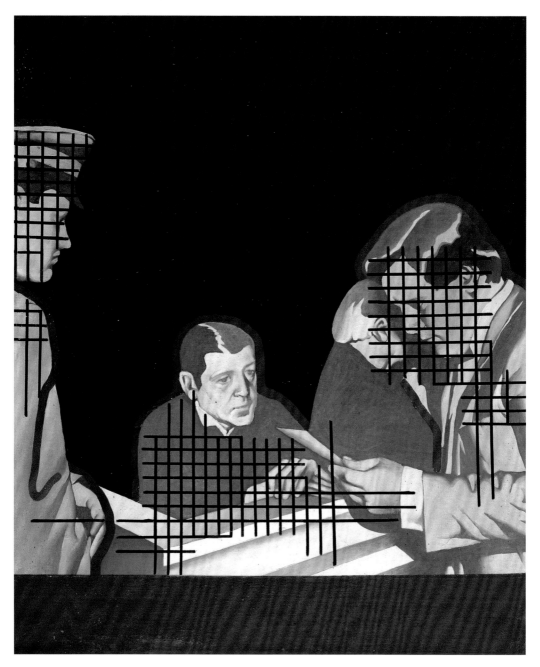

Wang Guangyi,
International Politics: Necessary Documents, 1991
Oil on canvas, 120 x 100 cm (47¹/₄ x 39³/₈ in.)
Collection of the artist, Beijing, China

pp. 62–63
Wang Guangyi,
International Politics:
Necessary Parade,
1992
Oil on canvas,
120 x 150 cm
(47$\frac{1}{4}$ x 59 in.)

Wang Guangyi,
International Politics:
Necessary Wave
of the Hand, 1992
Oil on canvas,
120 x 150 cm
(47$\frac{1}{4}$ x 59 in.)

Wang Guangyi,
International Politics:
Necessary Signature,
1991
Oil on canvas,
120 x 150 cm
(47$\frac{1}{4}$ x 59 in.)
Private collection,
Beijing, China

Wang Guangyi,
International Politics:
Necessary Negotiation,
1991
Oil on canvas,
120 x 150 cm
(47$\frac{1}{4}$ x 59 in.)
Private collection,
Beijing, China

al problems. The story that *Visa* and *Eastern European Landscape* tell has to do with states and politics, but it is no longer cynical, closed or Cold-War-like; it is a story that is open and has a universal meaning. Furthermore, these pieces display some of the typical attributes of the artist's work: the directness of the sign, and the courageous initiative required to manage the tensions between different materials.[17]

Though these state-critical artworks were featured in all levels and types of international exhibitions, perhaps owing to their particularly sensitive theme or the limitations of the domestic environment, they had never been exhibited in China until the 1997 *First Contemporary Art Academic Invitational* held in Beijing. With this exhibition Wang Guangyi began applying his research to local social practice (though the works never reached the public because the exhibition was banned by officials). The first version of this work was *Everyone is a Potential Virus Carrier*. Wang Guangyi described it as such:

> This work tells the story of how the ancient and problematic theme of "others and hell" has been quickly vulgarized in contemporary society. Today, a kind of universal spirit of suspicion has become a kind of "civilized fashion" accepted by all. When we place this spirit of suspicion into the contemporary context, we get the feeling that everyone is suspect, so in this "vulgarized psychological story", we have all unconsciously become the catalysts of this "civilized fashion".[18]

This installation developed out of *Blood Test*. It expanded the criticism of the controlling power to the health system exerted over the individual body onto the entire society that controls the system. In this way the artist revealed the paradoxical relationship and psychological reality of controller and controlled who mutually control each other in contemporary civilization. The artist thus reaches similar conclusions to Foucault's theoretical analysis of "the docile body". The work that Wang Guangyi created for the exhibition is *Blood Test – Everyone is a Potential Virus Carrier*. It consisted of ready-made objects such as vegetables, fruits, supermarket shelves and hygiene posters. His analysis of the system was carried out on a much more concrete level: it showed the collaboration between the disease-control system and the hygiene propaganda used to attain control over the public. After this Wang Guangyi went on to create a batch of similar works such as *Quarantine – All Food is Potentially Poisonous* and *24-hour Food Degeneration Process*, to explore the influence that the civilization systems after the Cold War had on society and on the minds of individuals. These works also served to steer Wang Guangyi towards new artistic questions.

In his analysis of the system, Wang Guangyi applied a pathological reading of concrete ideological themes, giving his visual politics a methodological worth: he would often pre-establish certain themes to attract people's visual attention, but would avoid making superficial value judgements or critiques about them. Instead he would use images that had strong visual impacts as with *Visa* and *Blood Test*, and contextually suggestive mixed media (such as *The Similarities and Differences of Food Guarantees Under Two Political Systems* and *Quarantine – All Food is Potentially Poisonous*) to create moderate psychological suggestions that allowed the public not to focus on the meaning of interpretation of the image or materials but rather to concentrate on what was consciously or unconsciously "omitted" from the work.

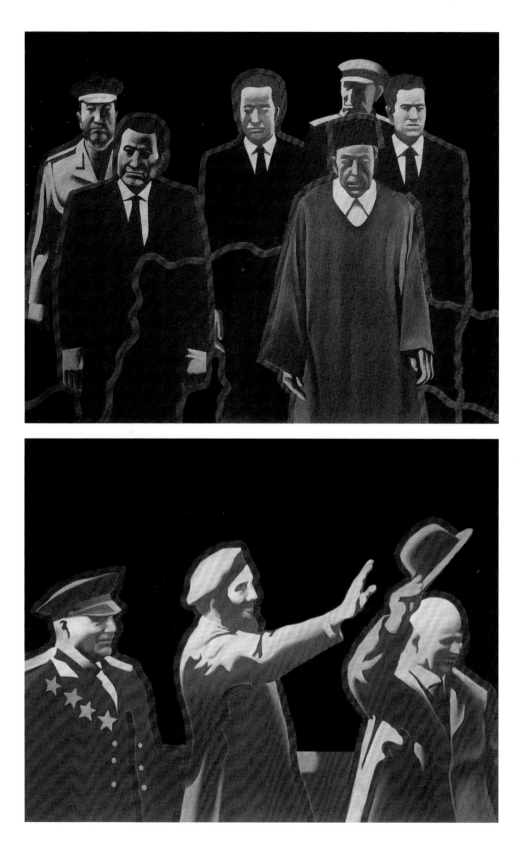

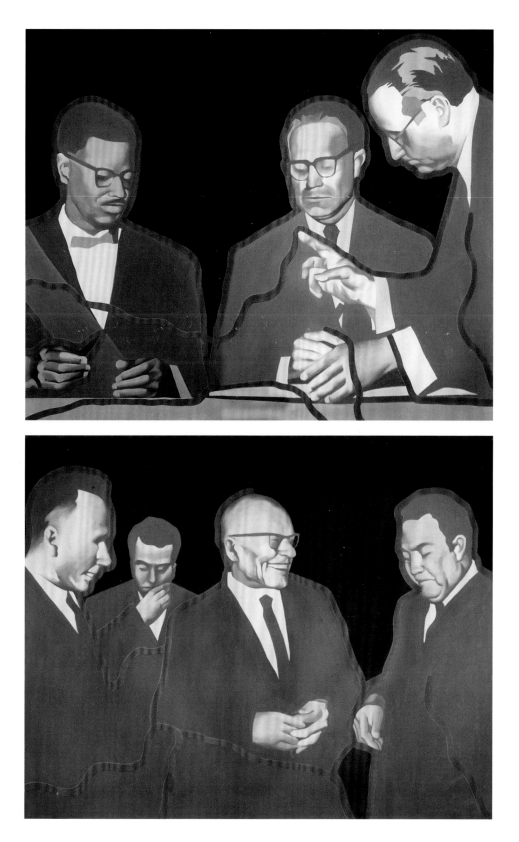

Wang Guangyi,
Visa, 1994
Artificial fur, pictures, wooden boxes, screen printing,
33 pieces, 120 x 80 x 60 cm
(47$^1/_4$ x 31$^1/_2$ x 23$^5/_8$ in.) each
Exhibited at *Visual Polity: Another Wang Guangyi*,
OCT Contemporary Art Terminal, He Xiangning
Art Museum, Shenzhen, China, 2008;
22nd São Paulo Biennial, São Paulo, Brazil, 1994

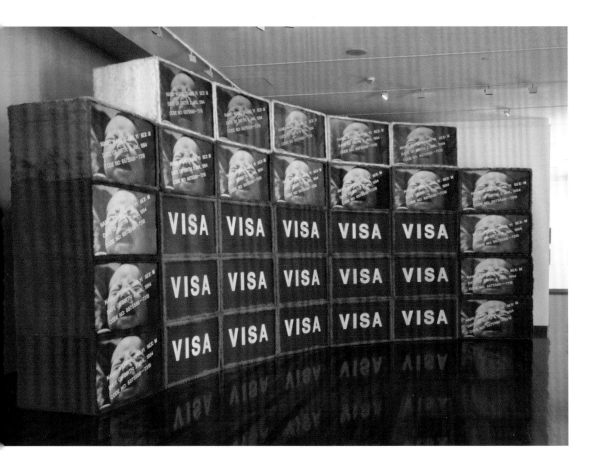

right
Wang Guangyi,
*Blood Test – Everybody Could Be
a Drug Addict*, 1996
Artificial fur, light boxes, glass, photos, foodstuffs,
500 x 800 x 300 cm (196$^7/_8$ x 315 x 118$^1/_8$ in.)
Partial view of the exhibition *Existence and
Environment the Chinese Way: The First Academic
Exhibition of Chinese Contemporary Art 96–97*,
Queensland Art Gallery, Brisbane, Australia, 1996
Photo by the artist

Wang Guangyi,
Materialists, 2001–02
Fibreglass and millet,
c. 180 x 120 x 60 cm
(70⁷/₈ x 47¹/₄ x 23⁵/₈ in.)
each
Collection of
Guangdong Museum
of Art, Guangzhou,
China, and others

Materialist Theology

According to Althusser, behind every strong ideological construction irrespective of the state apparatus's mode of production, the control relationship between subject and object must be established by a complete series of rituals and iconographic and narrative elaborations: "The subject fashioned by ideology is imaginary, for power only pretends to value it and has no true regard for its faculties. Power is only concerned with ensuring that the subject will misrecognize its subordination as self-determination".[19] In the late 1990s, China's society was a blend of two ideologies: on the one hand, socialism provided the basic set of values for controlling the state system and political life, which was complemented by highly spiritual and symbolic iconography that maintained the orthodoxy and legitimacy of the materialist mythology; on the other hand, consumer culture controlled the daily and economic lives of the Chinese through the values of individualism and freedom of choice typical of a market economy. At the same time, consumerism used materialist iconography in the media, internet, advertising and entertainment to establish a mythology of mass culture. The control enforced by these two ideologies makes up the foundation of contemporary Chinese society.

With his *Age of Materialism* (shown at the *Society* exhibition at the Upriver Art Gallery of Chengdu in 2000), Wang Guangyi's art reaches a new depth of inquiry. The work is made up of elements from the old ideological era and various kinds of material goods; the goal is to show the influence that the material world, the social system and cultural memory still exert over us. Here, the memories of the age of materialism and the banal desires of the age of consumerism enter into a more complex relationship.

In the works that followed, *Materialist*, *Monument to Labourers*, *The History of a Newspaper* and *East Wind – Golden Dragon*, the investigation into materialist ideology's mythological history became the focus of his work. He defined it as a "socialist visual experience",[20] which may seem to be a return to internal problems, but the content had already acquired deeper meaning. He paid special attention to the representation of the people and the processes of ritualization of the people-as-subject constructed within this mythological history.

On the surface, *Age of Materialism* seems to follow the visual modalities of *Great Criticism*, except that the people have shifted from being two-dimensional to being three-dimensional. In reality this work marks a disappearance of the dualistic logic of politics/consumption and East/West that is present in *Great Criticism* in favour of a more complex relationship to reality. Unlike the Pop methods in *Great Criticism*, which put propaganda images next to consumerist signs, this work highlights the subjective qualities within the representation of the people: they appear both historical and real, autonomous and submissive; they are both the symbolic body of power and the subject of control. Here, the coexistence of mythological memories and actual power shows the multifaceted nature of these classic icons of ideology. When the work was exhibited for the first time at the First Guangzhou Triennial of Contemporary Art, Wang Guangyi declared:

pp. 70–71
Wang Guangyi,
Materialists, 2001–02
Fibreglass and millet,
c. 180 x 120 x 60 cm
(70⁷/₈ x 47¹/₄ x 23⁵/₈ in.)
each
Exhibited at
*Reinterpretation:
A Decade of
Experimental Chinese
Art 1990–2000*,
The First Guangzhou
Triennial, Guangdong
Museum of Art,
Guangzhou, China,
2002
Collection of
Guangdong Museum
of Art, Guangzhou,
China, and others

> In these new sculpture works, I was trying to remove the obvious oppositional aspect, and take their simple, intrinsic, and perhaps less evident power – that is to say, I wanted to reconstruct the power and meaning of these socialist icons; a power and meaning that are directly linked to my life-experience, and are equivalent to the basic elements of our culture.[21]

Tian An Men square,
Beijing
Photo Zeng Li

Wang Guangyi,
Materialists, 2001–02
Fibreglass and millet,
c. 180 x 120 x 60 cm
(70⁷/₈ x 47¹/₄ x 23⁵/₈ in.)
each
Collection of
Guangdong Museum
of Art, Guangzhou,
China, and others

Wang Guangyi's work for the Fourth Shenzhen Contemporary Sculpture Exhibition in 2001 was also rooted in his interest in the relationship between the products of socialist ideology and the development of the spirit. The inspiration for the project *Monument to Labourers* (sometimes called *Forces of Nature*) was the old prefabricated concrete slabs that, having been abandoned in the streets, were covered with advertisements. The plan was this: to recreate 20 slabs of prefab concrete on-site and cover them with the names of model workers and dead or injured workers from Chinese Village in Shenzhen from the past 20 years, then cover the slabs with acrylic, so that each slab would become an alternative memorial plaque, and through this explore and express "some of the factors or relationships hidden in a picturesque glimpse of the human landscape".[22] In the *Monument to Labourers* that was actually exhibited, the sculptures were directly copied or appropriated from traditional worker's memorials and placed in glass cases, endowing these monuments that were so familiar to the Chinese with an estranged or alienated visual effect. The artist called attention to the implications of a new way of looking at workers within a consumerist space.

East Wind – Golden Dragon was the piece Wang Guangyi created for the *National Heritage* exhibition held in England. This show explored the recent meaning of the idea of nation within China from a theoretical and visual perspective; it also investigated the forms and pictorial elements (symbols, products, ceremonies, spaces) that marked the nation's shift from cultural organism to political and spiritual body. *East Wind – Golden Dragon* was the first automobile to

be designed by the Chinese people after the establishment of the People's Republic. As Mao's "mobile podium", it also became a symbol of political power, effectively illustrating the evolution of the automobile from an industrial product to an emblem of culture, politics and consumption. The work's object of inquiry is a modern industrial product understood as the historic relationship between political utopia and consumerism:

> *East Wind – Golden Dragon* was a product of China's industrial revolution dreams. Countless people worked tirelessly to complete it and give it to Chairman Mao. It was an industrial product that was full of belief; a last homage to the imperial power. Reproducing it today in the name of art expresses the conflict between belief and material desire. *East Wind – Golden Dragon* is a material testament to national heritage, and it also shows the relationship between power and the will of the people. National heritage often covers both of these levels. I will use cast

Wang Guangyi,
study for *Monument
to Labourers*, 2001
Acrylic, felt-tip pen
and ink on paper,
26 x 30 cm
(10¹/₄ x 11³/₄ in.)

Wang Guangyi,
*Monument to
Labourers*, 2001
Fibreglass and millet,
c. 180 x 120 x 60 cm
(70⁷/₈ x 47¹/₄ x 23⁵/₈ in.)
Partial view of the
exhibition *Transplantation
in Situ*, He Xiangning
Art Museum, Shenzhen,
China, 2001

iron to reproduce the *East Wind – Golden Dragon* in full scale, I will give the work a museum feel and thus allow it to contain the weight of history – the strong desire of a people to grow, or the multifaceted nature of desire. Simply put, *East Wind – Golden Dragon* is a product of belief. In other words, it is in itself an offering to China's industrial revolution.[23]

In the 1980s Wang Guangyi was a cultural utopian in the traditional sense. In the early 1990s he used Pop to dispel the rational mythology of the Enlightenment and replace it with satire. In his *Materialist* series he began to turn the cultural memories and spiritual myths of the age of materialism and the crazed desires of the age of consumerism into subjects of a dual investigation, collocating the two different ideologies within a clearer historical logic. He used conceptualist methods to document the utopian heroism that still permeated a now thoroughly material society, concealing a sophisticated idealist spirit within this new depth of investigation.

Wang Guangyi,
studies for *East Wind –
Golden Dragon*, 2006
Acrylic and oil on
photocopy, 21 x 30 cm
(8¼ x 11¾ in.) each
Collection of the artist,
Beijing, China

Wang Guangyi,
*East Wind – Golden
Dragon*, 2006–07
Car iron
Exhibited at *Art for the
World: The Sculpture
Project of the EXPO
Boulevard*, Shanghai
World Expo 2010,
Shanghai, China, 2010

Wang Guangyi,
studies for *East Wind –
Golden Dragon*,
2006–07
Acrylic and oil on
photocopy, 30 x 21 cm
(11³/₄ x 8¹/₄ in.) each
Collection of the artist,
Beijing, China

Mao Zedong viewing
the car with Lin Boqu
and FAW workers in
Zhong Nan Hai, 1958

left
Wang Guangyi,
*East Wind – Golden
Dragon*, 2006–07
Fibreglass, photograph,
500 x 190 x 165 cm
(196⁷/₈ x 74³/₄ x 65 in.)
Exhibited at *State
Legacy: A Visual
History Project on the
State Concept*,
Manchester Institute
for Research and
Innovation in Art and
Design, Manchester,
Great Britain, 2009
Photo Wang Junyi

Cold War Aesthetics

As one of the most interesting contemporary artists in China, Wang Guangyi
seems to leave his mark at every junction of art history: from the rationalist paint-
ing of the arctic period to the analytics of the post-classical period, from the sup-
pression of humanist passions to *Great Criticism*, from the study of Eastern and
Western political systems to the reshaping of the visual mythology of local ma-
terialism. It is within this infinite practice of investigation into art history that he
gradually formed his visual politics. The historic-political sources that serve as the
basis of his visual politics are not the model by which to express pre-established
political concepts, but aid in the formation of his individual visual strategy and di-
alectical wittiness. He has always maintained a careful neutral attitude towards
history and politics, one that is devoid of hasty value judgements. With an un-
flappable attitude of derision, Wang Guangyi does not remove the gravity of po-
litical topics. In this way his attitude is very similar to Joseph Beuys's: he does
not care about the art of politics, only about the politics of art. It is the insepa-
rability between the desire to transcend reality and the desire to penetrate it with
courage that makes his role in contemporary Chinese art more like that of a his-
torical soothsayer than a pure critic. Perhaps this is the real reason why critics
consider him an artist who embodies the qualities of both Beuys and Warhol.

 In 2007, Wang Guangyi played another card from his visual politics deck:
Cold War Aesthetics. This giant visual project also made use of dual historical

Sir Winston Churchill, Franklin D. Roosevelt and Joseph Stalin in the last meeting of the Yalta Conference, 1945

Chairman Mao shown chatting with steel workers while inspecting a factory in Anhwei Province, 1959

Chairman Mao greets Richard Nixon in a private meeting, 21 February 1972

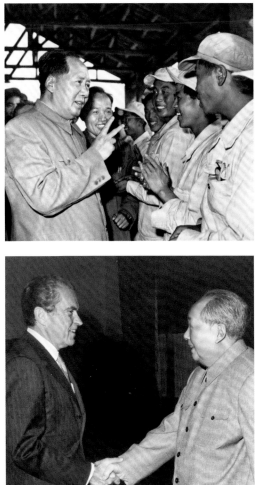

Fidel Castro and Nikita Khrushchev in New York
during the United Nations General Assembly,
September 1960

Mao Zedong announces
the founding of the
People's Republic of
China, 1 October 1949

pp. 84–86
Wang Guangyi,
studies for *Cold War
Aesthetics*, 2007
Acrylic and felt-tip pen
on photocopy,
30 x 21 cm
(11³/₄ x 8¹/₄ in) each
Collection of the artist,
Beijing, China

and political sources. Guangyi uses a nationwide civilian military preparedness exercise from the height of the Cold War as the backdrop, through which he deploys the visual illusions associated with the real world. "Three Warfares" (against atomic, chemical and biological weapons) is the name of a national defence education movement that existed in the 1960s when Sino-Soviet relations were at their worst. It has virtually all of the political traits of the Cold War: a highly specific hypothetical enemy, an important ideological apparatus and a range of relevance that touched the entire populace. Compared to the Cultural Revolution, which took place at the same time within the confines of the country, the movement was markedly more international in nature. It is obvious that just like *Great Criticism*, with its usage of political iconography, *Cold War Aesthetics* is not about dredging up our visual memories of the movement but about the present. Here is how the artist describes it:

> The Cold War had a brutal side, which was part of the shared imaginary, and for us kids it also had a playful side. At the same time, it influenced our perception of the world, which to this day we still view with a Cold War mentality. Today's politics are the fruit of seeds planted during the Cold War; it is the same with 9/11, and the same with Al-Qaeda. These are all different means of expression that derive from the Cold War.[24]

Of course, we cannot limit ourselves to the description Wang Guangyi gives of his own work. Perhaps what he's really interested in is the fact that the Cold War has provided him another opportunity to activate his visual and verbal wit. This fits nicely with his artistic personality: letting himself stray far from his own work

84

Wang Guangyi,
study for *Cold War Aesthetics*, 2007
Oil on canvas, 100 x 80 cm (39⅜ x 31½ in.)
Collection of the artist, Beijing, China

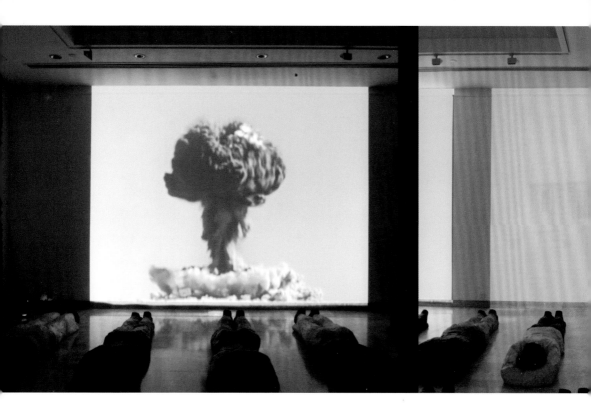

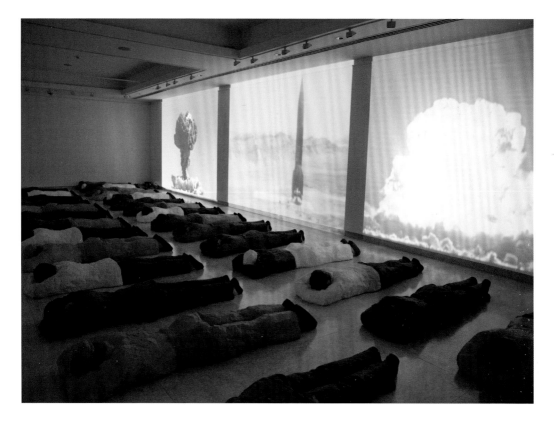

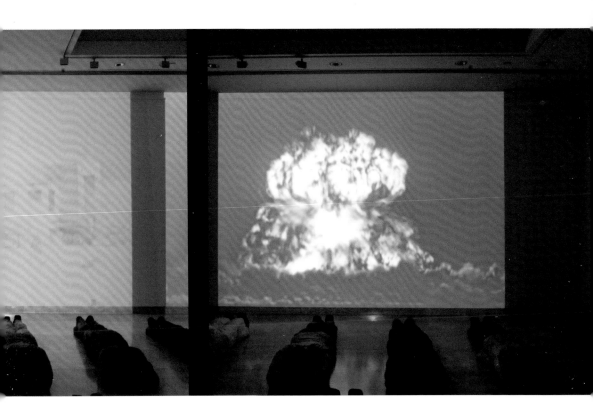

Wang Guangyi,
*Cold War Aesthetics:
People Living in Fear*,
2007–08
Coloured fibreglass,
video, 30 sculptures,
215 x 60 x 30 cm
(84⅝ x 23⅝ x 11¾ in.)
each
Partial view of the
exhibition *Visual Polity:
Another Wang Guangyi*,
OCT Contemporary Art
Terminal, He Xiangning
Art Museum,
Shenzhen, China, 2008
Photo Xiao Quan

pp. 90–91
Wang Guangyi,
detail of *Cold War
Aesthetics: People
Living in Fear*, 2007–08

and from the visual imaginary he used as a model so that it would expand in meaning and depth through the discussions of others. That is exactly what he calls aesthetics:

> As I see it, my art is searching for dualistically opposed forces. The Cold War mentality fits with many of my own ideas. The Cold War mentality has shaped a lot of my views on the world and art. In this way, if we imagine an enemy, this enemy becomes the starting point for all our behaviour. The flip side is the same. Our enemies will imagine us to be their enemies, and that's the beauty of this world, the beauty lies in this opposition, in existing within this plethora of oppositions.[25]

Cold War Aesthetics is marked by the same methodological traits as *Great Criticism*, *Visa*, *Materialist* and *Face of Faith*, except that what is being reproduced are no longer images of a crazy senseless history but rather historical scenes that are cold to the point of being both suffocating and enchanting. Enlarged and solidified, these scenes seem like an historical catalyst capable of providing us with a new field of vision for understanding the meaning of life and the world. Perhaps this work has returned to the external problems mentioned earlier, but placed within a wider reflective framework.

The Cold War is a political inheritance left to mankind by the twentieth century. It wasn't a conclusion of history but a new seed that was planted into human history. The Korean War, the Vietnam War, nuclear testing, China's Cultural Revolution, the 1968 uprisings across Europe, the Beatles and rock'n' roll and the space race: all of these real historical events not only influence our psychological orientation and cultural personalities – they also influence the future

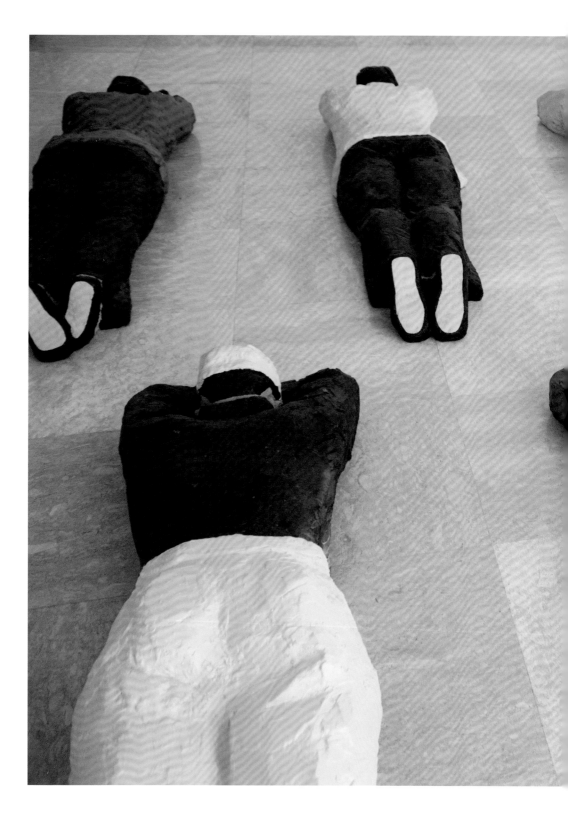

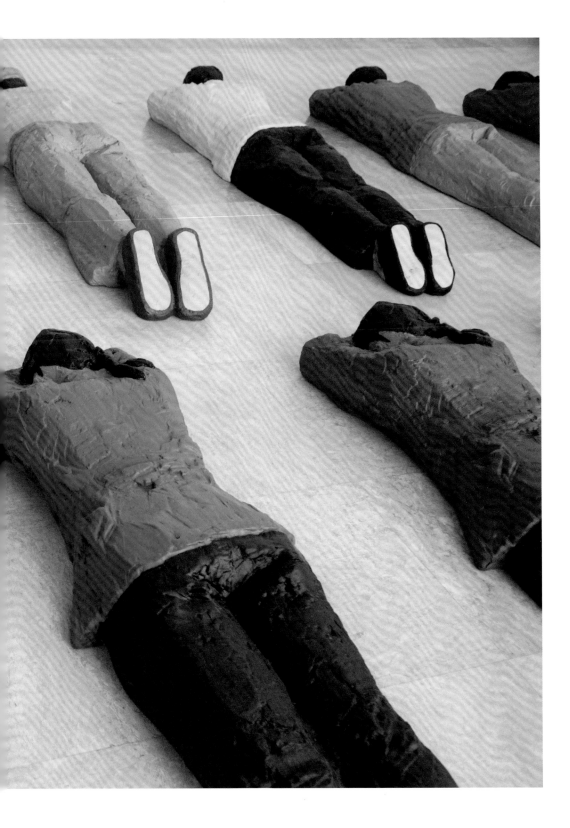

The Cold War Aesthetics

草地可'奇树

200cm

40-170cm

用青铜雕的方法

400cm

2008年川总义

坐在有概念的物策中，着色。

玻璃钢上色

→ 500cm ←

1.6米

200cm

冷战美学.

陈室间平面图

可抽玻璃

2008年九芝茶

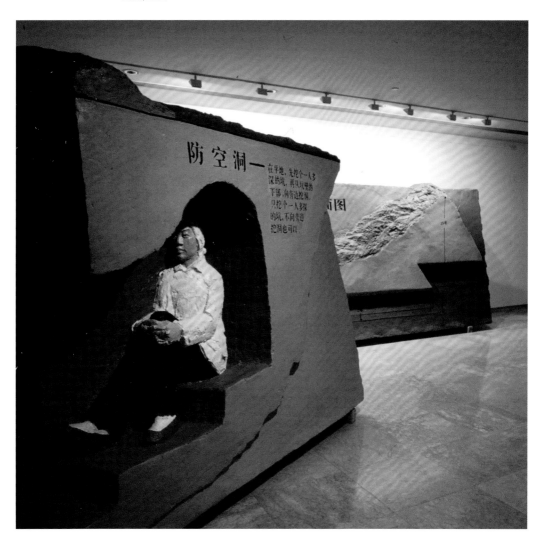

140-170

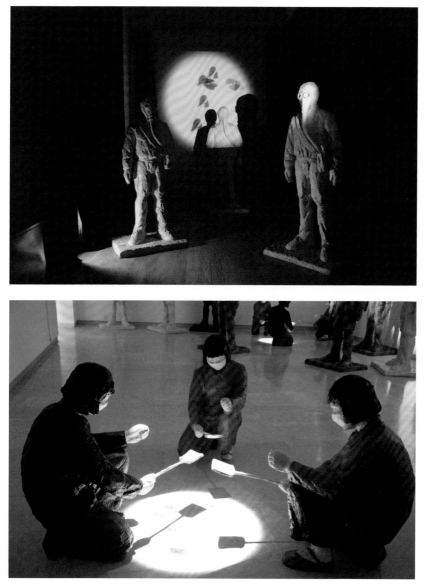

Wang Guangyi,
*Cold War Aesthetics:
Persons Wearing Gas
Mask*, 2007–08
Coloured fibreglass,
video, sculptures,
180 x 40 x 30 cm
(70⁷/₈ x 15³/₄ x 11³/₄ in.)
each

Wang Guangyi,
*Cold War Aesthetics:
Persons Killing
Virus-Carrying Insects*,
2007–08
Coloured fibreglass,
video, sculptures,
106 x 81 x 61 cm
(41³/₄ x 31⁷/₈ x 24 in.)
each
Partial view of the
exhibition *Visual Polity:
Another Wang Guangyi*,
OCT Contemporary Art
Terminal, He Xiangning
Art Museum, Shenzhen,
China, 2008
Photo Wang Junyi

right
Wang Guangyi,
detail of *Cold War
Aesthetics: Persons
Wearing Gas Mask*,
2007–08

pp. 96–97
Wang Guangyi,
studies for *Cold War
Aesthetics*, 2007
Acrylic and felt-tip pen
on photocopy,
30 x 21 cm
(11³/₄ x 8¹/₄ in) each
Collection of the artist,
Beijing, China

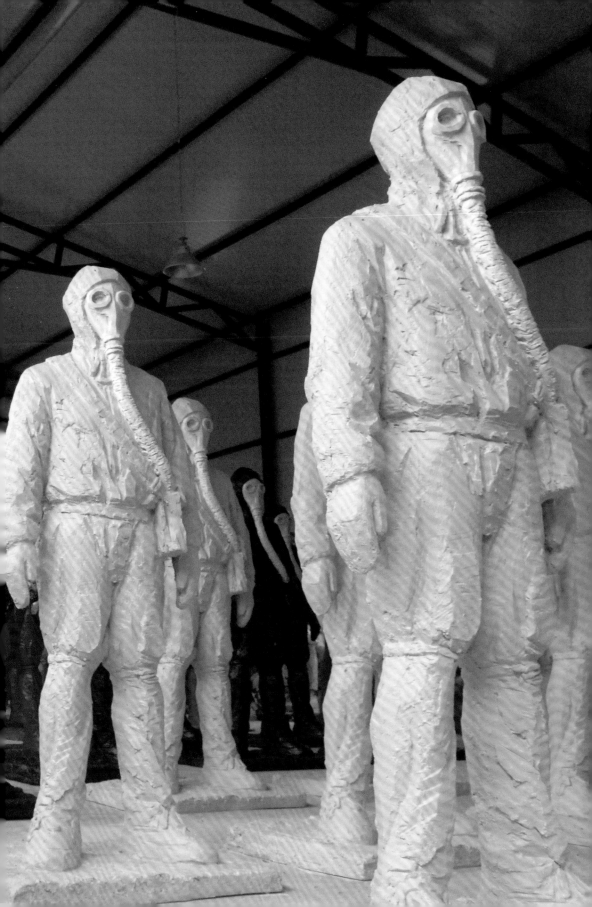

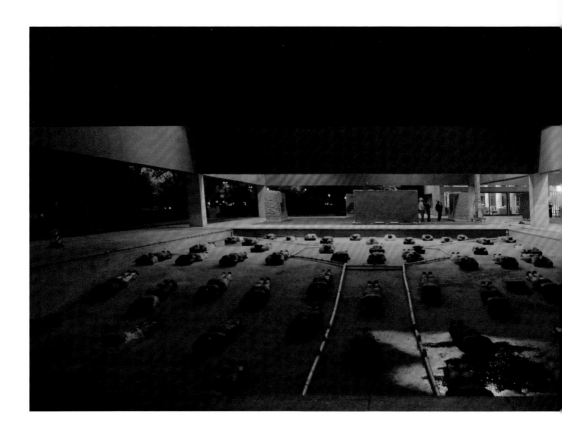

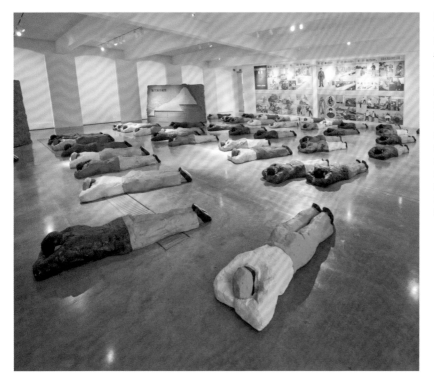

Partial view of the exhibition *Wang Guangyi: Cold War Aesthetics*, Pujiang Overseas Chinese Town Ten-year Public Art Project, Shanghai, China, 2012
Photo Wang Junyi

Partial views of the exhibition *Wang Guangyi: Cold War Aesthetics*, Louise Blouin Institute, London, Great Britain, 2008–09

direction of the world. In this sense, *Cold War Aesthetics* is a visual prophecy of a new history of the world as imagined by a Chinese artist.

While this essay was being written, Wang Guangyi experienced a personal political crisis that arose after the announcement of his withdrawal from a Chinese themed exhibition to be held at the Marseille Fine Arts Museum. Wang Guangyi withdrew himself to express his anger at the disruption of the Beijing Olympic Torch Relay ceremony in France. This act made him the target of strident criticism on the internet: it was seen as a risk-free patriotic spectacle, and the artist was judged a superficial democrat. Though these attacks were far removed from artistic issues, falling instead within the realm of illogical personal attacks, this episode showed that in comparison to Wang Guangyi the artist, Wang Guangyi the public figure lacked a visual politics with which to face the real world. Just like in the art world, "correct" political positions and behaviours are no guarantee that the outcome will be likewise. In the end, this world is divided by interest.

In this section we have seen another Wang Guangyi. We don't know if this Wang Guangyi, when compared to the Wang Guangyi who has been called the "father of Chinese Political Pop", or to the Wang Guangyi who has been shaped by publicity and the market, will prove to be closer to the true Wang Guangyi. Perhaps the "real" Wang Guangyi never existed.

Part Two

Theology in Art

"In the Middle Ages, it has been customary to compare God with
the artist in order to explain the nature of divine creation; later the artist
was compared with God in order to theroize artistic activity. This was
the moment when he began to be called *divino*."

<div align="right">

Erwin Panofsky, *Idea: A Concept in Art Theory*[26]

</div>

In the first part of this book we have discussed the political aspects of Wang
Guangyi's art, which constitute an important component of his public persona,
but they far from represent the entirety of his artistic universe. In fact, one could
say that when compared to other facets of his work – ones more pertinent to the
intriguing transcendental sphere – these political aspects are a mere veil.

Nietzsche said that the "conceptual fabrication" between the apparent
world (false) and the real world (true) is the root of all the disasters of the real
world. He did not, however, claim to be a materialist atheist. What he wished to
free himself from was the historical authority of a god who was understood as a
rational idol with no proof of existence (his non-existence is evidence of his ex-
istence), and replace it with a kind of personal myth – the mythology of the artist
as the superman or *Übermensch*: "Our religion, morality and philosophy are deca-
dence-forms of man. The countermovement: art!"[27]

Wang Guangyi's artistic world is permeated by the aura of this individ-
ual mythology, but unlike Nietzsche's, his world tells of the contradictory indivis-
ibility between faith understood as enlightenment and the wisdom derived from
rationality. He still believes that there is a mysterious transcendental world be-
hind our worldly experience, a "thing-in-itself" for which he has always had pro-
found respect and attraction. The artist affirms that imagining the existence of an
absolute God has given him a sense of certainty in the real world, and this has
led him to keep a wary distance from Nietzsche's irreversible nihilism.

The Problem of Theology in Western Art History

All artistic discourse is rooted in Plato's part-philosophical, part-mystical reflec-
tion on the mimesis of ideas (whether or not ideas can be imitated and how); it
has given birth to all the questions and various answers posed through the course
of classical, modern and contemporary art history.

Though Plato did not assign any legislative power to artists, his distinc-
tion between the two types of "appearance-making" (human imitation that uses
the self as the tool in creation) – belief mimicry and informed mimicry – leaves space
for later artists to aspire for the right to make their own "divine creation". Aristo-
tle replaces the dichotomy between ideas and perceivable things with the con-
cept of universals and particulars, bringing Plato's transcendental objects to the
same level as human intellect. Reading Aristotle's theory in a particular way al-
lows artists the possibility of legitimately pursuing artistic activity. If the substance
is derived from the form, this shift away from Plato creates the possibility of equat-
ing artistic activity with divine creation. Plotinus selected a kind of trinitarian so-
lution that bridged the gap between Plato's transcendentalism and Aristotle's em-
piricism to explain the reciprocal relationship between the universe, the soul and
the senses. His doctrine bestowed artists with the essence of "nous" – a kind of
mystical and creative ability of the soul that has the power to transcend the indi-
vidual and nature. The work of art is the outpour of this immaterial internal form

Wang Guangyi,
Madonna and Child, 1989
Oil on canvas, 120 x 100 cm (47¹/₄ x 39³/₈ in.)

Diego Velázquez,
Portrait of Infant Margaret of Austria,
c. 1660
Oil on canvas,
212 x 147 cm
(83¹/₂ x 57⁷/₂ in.)
Museo Nacional del Prado, Madrid, Spain

Salvador Dalí,
The Pearl, 1981
Oil on canvas,
140 x 100 cm
(55¹/₈ x 39³/₈ in.)
Fundació Gala-Salvador Dalí, Figueres, Spain

into the inactive material world so that man, like God, can create. Like Plato's, Plotinus's solution also tends to reject the perceivable world, but it confirms that artists can use intuition to access the mysterious universe by looking inwards. After this, the question of how to overcome the dualistic conflict between the visible and intelligible world becomes the primary question that art must answer.

The anthropomorphic God of Christianity has drawn and reconstructed Plato's non-anthropomorphic world of ideas in various ways. The theory of creation from nothing and the salvation of the body through free will provide a more complete transcendental theology, while, in the Middle Ages, Christian theology's affirmation of individual salvation and confession became the prerequisite for responding to the dualism of neo-Platonism. In comparing divine creation with the artist's act of creating beauty, Augustine bestows upon the artist the sacredness of the divine: artistic creations possess a mystical nature of Pythagorean design; they are the symbolic representations of universal transcendence, unity and harmonious order. This logic constitutes the psychological basis for the artist to serve as God's spokesperson. Thomas Aquinas does not provide any further theological proof of the unity of beauty and goodness that marks artistic creation, but he constructs an Aristotelian logic for these activities in order to maintain a certain balance between the empirical and the transcendental worlds. The question of the relationship between the a priori wisdom of the artist and the empirical activities of the natural world, however, would not be proposed until the Renaissance.

The Renaissance unearthed the concept of the faithful imitation of reality with regard to the artwork of the classical period, while also awakening the idea of a faith capable of transcending nature. Reflections on subjectivity and objectivity, together with the discussion of the rules of art including the concept of

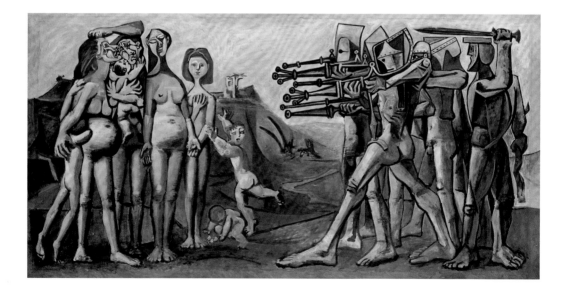

order, numbers and proportions, made it possible for artists to pursue the creation of a world of concordant, balanced and harmonious beauty, which for the first time, broke the link between the beautiful and the good.

Though until the late Renaissance neo-Platonism was still the authority on divine creation, the importance Aristotle placed on the empirical activities of the senses (especially visual and auditory activities) in achieving divine creation, foreshadowed certain formal characteristics of recent aesthetics. Artists were no longer satisfied with being mere spokespersons for God. The emergence of reflections on inspiration, talent and artistic order created immense ambition:

> God's spokesperson aspired to become God.

Cultural Utopia

There is nothing outlandish about the assertion that Wang Guangyi's works in the 1980s are inextricably linked to the theological and artistic questions mentioned above. In fact, whether real or imaginary, Wang Guangyi has always affirmed that there are two worlds: a transcendental, rational and orderly classical world, and a sensory, irrational and chaotic contemporary one. The classical world is a necessary world tied to religion, myth, prophecy, heroism and enlightened faith, while the contemporary one is random, idolatrous, realistic and cynical. In his experience, both of these worlds truly exist and his art is like a chess match between these two intertwined worlds.

In 1984, when what would later be called the '85 New Wave art movement was just beginning, Guangyi and his academic peers founded China's first avant-garde art group, the Northern Art Group. In a series of manifestic essays, he described their motivations: unlike the clearly anti-ideological bent of the Stars Group and the various formal avant-garde experiments popular at the time, and even unlike the critical enlightenment mentality of the '85 New Wave art movement, they established the artistic goal of "creating a world" that was completely new, and supported by a theology of revelation. [This text uses the term "theology" in the broadest sense, not just to refer to Platonic or Christian theology but also to all ideas and concepts related to transcendental questions, similar to

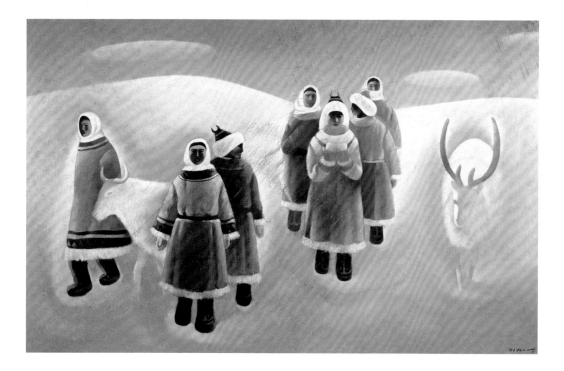

the definition that Bertrand Russell provides in his comparison between science and philosophy: "It consists of speculations on matters as to which definite knowledge has, so far, been unascertainable"; Bertrand Russell, *History of Western Philosophy*, introduction. *Translator's note*] Wang Guangyi and his colleagues called in this the Northern Civilization. The assumed enemy of their artistic goal was not authority-supported culture or art (as the '85 New Wave guys had declared), but the various "Rococo-inspired artistic expressions" and morose, purely formalist arts. The subtle differences between this goal and those of the '85 New Wave art movement are quite thought-provoking, even though the Northern Art Group has always been characterized by its promotion of "rational painting":

> Life's internal driving force – that force behind culture – has today truly been raised to a higher level! We yearn for and "happily watch all forms of life" to establish a new, more human-oriented spiritual mode, capable of bringing more order to life's process of evolution. To this end, we are opposed to those pathological, Rococo-inspired artistic expressions, and all things that are unhealthy and detrimental to the evolution of life, because they promote mankind's weaker aspects, leading man away from health and life. … We are opposed to those so-called deliberations on questions of pure artistic form, because excessive research into those questions will lead to a flood of pathologically formalist art, and lead man to forget his condition. For this reason, we newly propose an ancient topic – that content determines form. Our creations are not art! They are prophecies regarding a new culture (the Northern culture). The reason we have chosen painting as the medium for transmitting these prophecies is that the act of producing images that is painting possesses an unfathomability within its depths that approaches the ultimate essence of truth.[28]

This artistic principle is a bizarre harmonization of Hegel's philosophy of history and Nietzsche's philosophy of life, with its key words being creation, order and ultimate essence. As a theological concept, creation for Plato was the action through which the gods used ideas to create a new form for ordering the natural world; for Aristotle, creation is the manifestation of the final cause through the material cause, the formal cause and the efficient cause; for Augustine and Thomas Aquinas, creation is God's gratuitous, transcendental making of the world out of nothing; for Hegel, it is the historical progression of the absolute spirit; while for modernist progressivism, creation is represented by man's ceaseless godlike innovations. Wang Guangyi's creation might seem like a modernist cultural slogan ("to increase humanity's harmony with the sublime and nature; to establish a new spiritual mode"), but it actually also has more oracular implications, emphasizing the transcendence of aesthetic and sensory expressions of the rational order of the universe and the spirit. This is a typical product of Hegel's spiritual theology. Wang Guangyi decided to choose an artistic form that fit with this neo-Platonist-Hegelian principle, moving him closer to the "Strasbourg Cathedral":

> The painting that possesses a sense of elevation should in appearance have a form akin to the Strasbourg Cathedral, which rises into the sky, lofty and magnificent, casting a wide shadow around it. Its massive and harmonious size is capable of conveying the beauty of lofty ideas, encapsulating the perpetual harmony of the healthiest human emotions. Here, the creator and the created perceive tranquillity and majesty, rather than just appreciative joy in the usual sense. As the human spiritual state materialized in such a painting approaches the archetypal beauty of the most elevated ideas, this beauty possesses human truth in the

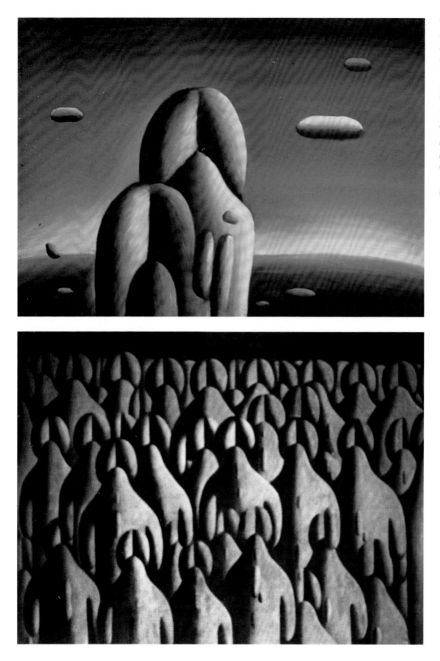

Wang Guangyi,
*Frozen North Pole
No. 26*, 1985
Oil on canvas,
70 x 85 cm
(27$^1/_2$ x 33$^1/_2$ in.)
Collection of the artist,
Beijing, China

Wang Guangyi,
*Frozen North Pole
No. 27*, 1985
Oil on canvas,
160 x 200 cm
(63 x 78$^3/_4$ in.)

deepest sense, and the perceptions derived from it may more deeply permeate mankind's healthy spirit.[29]

In 1984 and 1985, Wang Guangyi created the *Frozen North Pole* series, which can be seen as the visual equivalent of this sort of theological manifesto. In fact, according to critics, he began to display an obsession with classical painting techniques from his beginning as a student of oil painting at the Zhejiang Academy of Fine Arts. This positions him in stark contrast to the oppositional attitudes that were prevalent among the various new modernist styles, and isolated him in the

Academy, which was so renowned for its openness. In a letter to one of his schoolmates, Wang Guangyi frankly expressed the connection between this particular taste and his theoretical interests:

> At the time, the readings that were disseminated among the students of your year had a great influence on me. My interests, however, were different from yours. You were interested in political philosophy and the natural sciences, while I was interested in the philosophy of religion and Existentialism. My favourite books were those by Thomas Aquinas, Nietzsche and Sartre, and I later came to be quite interested in mediaeval theology, while you moved towards modern philosophy of science. I was fascinated by classical and mysterious things while you liked modernity, and analytical things. My philosophical interests and my artistic vision at the time had a mutual influence over each other. To be clear, I do not like the

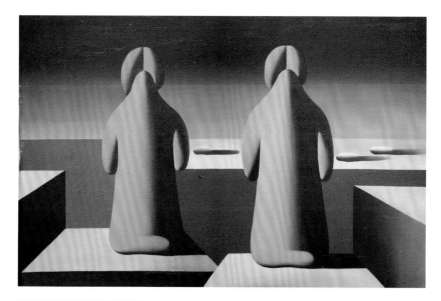

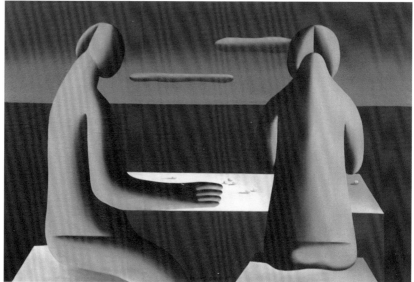

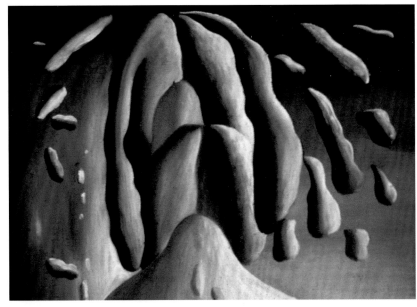

Wang Guangyi,
*Frozen North Pole
No. 30*, 1985
Oil on canvas,
70 x 85 cm
(27$^1/_2$ x 33$^1/_2$ in.)
Collection of the artist,
Beijing, China

Wang Guangyi,
*Frozen North Pole
No. 31*, 1985
Oil on canvas,
160 x 200 cm
(63 x 78$^3/_4$ in.)
Collection of the artist,
Beijing, China

work of the Impressionists. After making a few such paintings, I came to feel that it was very superficial, a mere retinal game, like a scientific experiment lacking internal depth. It was around my second year at the Academy that I started to become entirely infatuated with mythology, and I suffered through the next two years.[30]

Frozen North Pole was a series of symbolist experimental works: symbolist in that they had all of the traits of classical symbolism, and experimental because they were created through a series of "Cézanne-esque" abstractions. According to Johan Huizinga, "Symbolism's image of the world is distinguished by impeccable

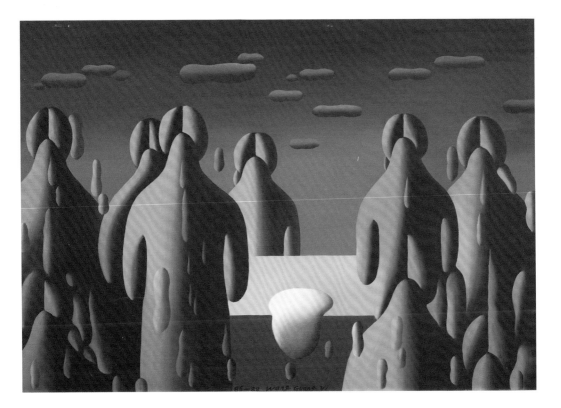

order, architectonic structure, hierarchic subordination. ... Symbolist thought permits of an infinity of relations between things".[31] The psychological foundation of symbolism arises from people's concentration of all the perceptive faculties of the phenomenal world onto the absolute Being. Through this, a faith, understood as a process that is in a constant state of becoming, is established, a faith that intuits the common essence which joins all things worldly:

> In God, nothing is empty of sense: *nihil vacuum neque sine signo apud Deum*, said Saint Irenaeus. So the conviction of a transcendental meaning in all things seeks to formulate itself. About the figure of the Divinity a majestic system of correlated figures crystallizes, which all have references to Him, because all things derive their meaning from Him. The world unfolds itself like a vast whole of symbols, like a cathedral of ideas. It is the most richly rhythmical conception of the world, a polyphonous expression of eternal harmony.[32]

Frozen North Pole was a result of this "most richly rhythmical conception of the world" and a series of "Cézanne-esque" experiments on abstraction and natural models. For Cézanne, the surpassing of classical perspective methods and the Impressionists' treatment of light became the natural starting point for his sorting out of the inherent chaos of subjective perception. He hoped, through the chaotic organization of natural lines (landscapes, portraits and still lifes), to bestow on them a stable and objectivist order so as to reformulate Poussin's brushstroke as he draws nature. Though Cézanne's work lacked theological intent, and his interpretation of Plato's idea of imitation was devoid of metaphysical connotation – he wanted to understand how man could recreate nature without any

Jacques-Louis David,
The Death of Marat, 1793
Oil on canvas, 165 x 128 cm (65 x 50³/₈ in.)
Musées Royaux des Beaux-Arts de Belgique,
Brussels, Belgium

right
Wang Guangyi,
Post-Classical: Death of Marat A, 1987
Oil on canvas, 116 x 166 cm (45⁵/₈ x 65³/₈ in.)
Collection of Tang Buyun, Chengdu, China

Wang Guangyi,
Post-Classical: Death of Marat B, 1987
Oil on canvas, 160 x 200 cm (63 x 78³/₄ in.)
M+ Sigg Collection, Hong Kong, China

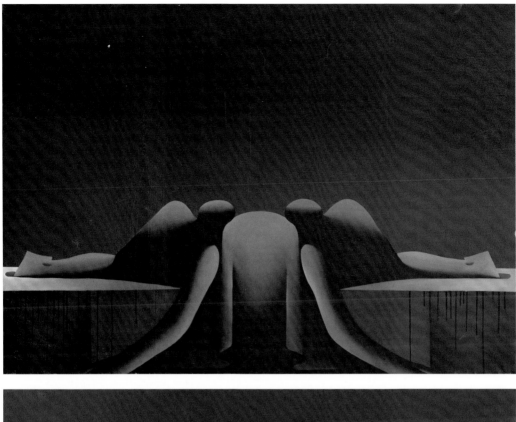

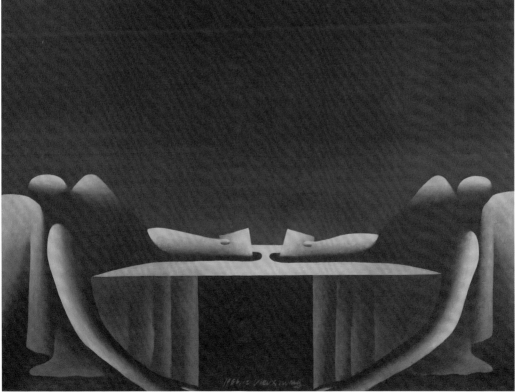

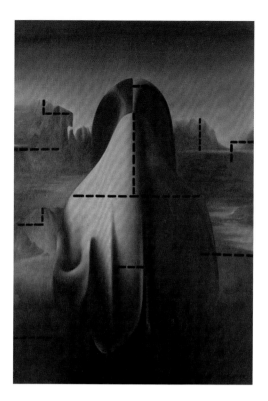

Wang Guangyi,
*Post-Classical: Back
of Mona Lisa B*, 1986
Oil on canvas,
87 x 67 cm
(34¼ x 26⅜ in.)

right
Wang Guangyi,
*Big Doll – Madonna
and Child*, 1988
Oil on canvas,
160 x 117 cm
(63 x 46 in.)
M+ Sigg Collection,
Hong Kong, China

Wang Guangyi,
*Post-Classical:
Madonna and Child*
aka *The Trinity*, 1988
Oil on canvas,
150 x 100 cm
(59 x 39⅜ in.)
Private collection,
Chengdu, China

subjective emotions – the classical aura of his works still had a powerful impact on Wang Guangyi, who, at the time, was searching for a new expressive technique. Of particular interest was Cézanne's exhortation: "Treat nature by the cylinder, the sphere, the cone, everything in proper perspective so that each side of an object or a plane is directed towards a central point",[33] which was revelatory for Wang Guangyi's artistic development and research.

Unlike Cézanne, the matrix chosen for *Frozen North Pole* was not nature in general, but snow in particular. Guangyi's 1984 thesis, *Snow* was a standard Chinese academic-style piece. With its realist subject matter and virtuosity of technique, it seems quite ordinary, but the depiction of the living environment of the Evenki people contains some potentially abstract traits: an overhead view, frozen human and animal figures, a relatively unified colour tone and the overall impression of tranquillity provide a visual foundation for the next stage of his work. Soon after, another formal matrix became part of his technical painting practice. *The Back of Humanity* and *Gentle Back* were originally portraits of the artist's wife, though in breaking with convention by depicting her from behind: he completely avoided the simple reproduction of a figure perceived solely with the senses, and shifted the perspective towards certain structural analyses. In the artist's efforts to transcend sensory forms, his structured modelling method could be easily employed using such conceptualized image formulas.

Between 1985 and 1986, Wang Guangyi created over thirty paintings for *Frozen North Pole*. In the sketches and completed works that remain, we can see the internal logic of this experimentation. Two early paintings in the *Frozen North Pole* series reduced human and animal figures to a heightened simplicity;

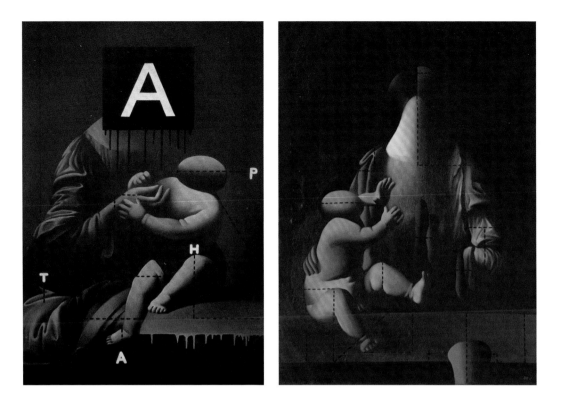

their structures assuming the geographical shapes of cylinders or cones, with only the clothing and thick boots providing clues to their identities as Northern nomads. Their pious postures convey a religious symbolic imaginary, which is enhanced by the high sideways lighting and the unified black and blue overall tone. In *Frozen North Pole No. 25*, the forms have been disassembled and rearranged into expansive structures; the humans, animals and heavenly bodies are geometrized into a precise fundamental architecture, while the typically mediaeval diagonal lighting alludes to the existence of time and space (in *The Heritage of Apelles*, Gombrich discusses the impact of this "formula of a diagonal shadow" in mediaeval painting[34]). These forms present a gentle and majestic solemnity that bears no relation to the perceivable world, as if they were a copy of the transcendental world. *Frozen North Pole No. 32* was the first to employ religious subject matter, but aside from the supper table, which denotes the setting, it has no visual element or theme that might compromise its fixed order. The geometrized human figures seen from behind and the static clouds maintain the sense of a majesty that transcends nature, while the only fluid object on the table evokes Salvador Dalí's *Persistence of Memory*, an allusion to time and remembrance.

 Frozen North Pole features, on the one hand, a process of refinement and abstraction of objects in order to grasp certain basic principles of symbolist representation. On the other hand, the use of personification and allegory transforms certain abstract concepts into mental images that can be recalled from memory, the goal of which being the differentiation between the *correct* images of the extrasensory world and the *false* images of the sensory world. The didactic nature of the depiction was the basic requirement of mediaeval neo-Platonists for

●本报地址：北京前海西街17号●　　●电话：65,5009　电报挂号：5018 1●

中國美術報

FINE ARTS IN CHINA　　1987第39期　（代号1—113）

艺术中的理性 ●刘彦

艺术是一种构造性活动。它是把人类的官能从偶然性中拯救出来的一种方式。这一目的虽然是通过感性来实现的，但是，它显然使人类的感觉理性化了。

我们所倡导的理性精神不是取消感性内容，不是逻辑程序，教条主义，不是以哲学代替一切，也不是用文学性来取代绘画性。所谓理性实际上是用人类的总体经验的概括和纯化相一致的。在艺术中贯彻理性精神，就是要让人类的共同经验在视觉的现象学平面上得以直接显现。

一些人强调艺术本身直觉，我认为艺术本身才是部分伟作大灵魂的直觉，这种真觉包含着对世界的深刻全面的认识，它是从一个充满理性构造的格式塔背景中突现出来的，并不是随便怎样一个骚动的灵魂都能为艺术酸造直觉和灵感。对世界缺乏全面深刻的认识、经验中没有丰富完整的理性构造、对人生缺乏理想、感官的偶然性骚动，即使形式上再接近直觉，也无法炼就其实质的平庸。

凡·高的热情之所以有艺术价值，是因为他对生命的炽烈的爱已经转化成对生命的超乎寻常的准确认识和本质把握了。凡·高的真正本质不是疯狂，而是用理想来驾驭疯狂的难能品质。

巴赫的音乐为我们的论题提供了最有力的证明。如果说艺术同理性是相互排斥的东西，我们就无法理解德国这个民族的成就，它同时为人类创造了诗歌、音乐和理性主义哲学。

理性和感性的相互融合和强化乃是一种文化高度发展并处于上升期的标志。让我们可以举希腊、文艺复兴、18—19世纪德国以及法国的后期印象派为例。相反，文化走向死亡或尚未成熟被表现为这种统一的瓦解或不完满。比如基督教统治的中世纪文化，西方现代派等等。

过分强调自由和无意识不会给艺术带来本质的出路。自由并不意味着对人类的创造性意志交给动物的偶然性。"自由是认识了的必然"。人类没有理性就没有自由，那种想把人类重新交给偶然性去支配的人仅仅表明他们没有能力向负起人类的伟大使命，也没有控制其官能而创造崇高的才能。

东方造型艺术的不足方面就在于缺乏构造性，这反浅了东方文化中缺乏逻辑深度。西方现代文化来自希腊文明，而希腊文明的特征不是诗歌，是它在两千年前就为人类建立了比较完善的演绎思维方法，这一成就有着普希腊理性与感性相平衡的完美素质，而在我们看来，希望人的理性精神并没有取消他们的感性，相反，使得他们在艺术上取得了远远超出其它文明的光荣。

今天，世界文化正处在一个特殊的非平衡态，它的特征在于文化审看着各个方位的单向的高度发达、文化是分析式的而非综合的。

（下转第二版简讯栏）

王广义

作品

自上而下：

1　后古典系列——马太福音 （200×200厘米）
这不是人类一般情感的表达，也不是赏心悦目的温情境界，那是一种借鉴私塑造了的基督教文化中"大人类精神"的氛围，它使纯个人的精神在一种崇高感的笼罩下得到升华，后古典系列就是在寻找与这种境界相对应的图式。《马太福音》用了两个对称的原型造型的使设，一块地方形的观念性黑色和流淌而下的黑线的造型，以召示一种类似宗教感的静穆、崇高的悲剧气氛。

2　黑色理性——病理分析A
3　红色理性——偶象的修正

（站在画面的是作者）

这两幅油画中的红格子和黑格子带有一种对文化史中疾病因素的否定意味，同时在视觉上有一种扩充和向上展开的力量感。

编者按：本报新开设的"新潮美术家"专栏，目前还偏重于作品和艺术主张的介绍，意在引起更深入的探索、讨论和批评。

新潮美术家（二）王广义

王广义，1957年生，哈尔滨人。1980年入浙江美术学院油画系，初期受西方表现主义及凡·高、马蒂斯、毕加索影响。后对西方古典主义油画和古典哲学发生了浓厚的兴趣。1984年毕业时，便彻底与表现主义及毕加索一类风格决裂了，认为它们是"纯个人情感无目的的形式游戏，精神性不纯粹、不崇高。"回到哈尔滨后，参与组织了"北方艺术群体"。1984——1986年创作了《凝固的北方极地》，显露了他对以往文化中精神的超越。北方旷漠的冰冷感，稳定而简洁的构图，尤其是强调凝重的内敛力，单纯的木偶般造型，确立了他的"宗教感"——充溢庄严、静穆精神指向的基本图式。

近来，王广义"读了一些尼采和贡布里希的书，尼采使我明白怎样走出自身所处的困境，贡布里希给了我一点关于图式——文的修正和延续性方面的启示"（王广义）。文化上的横向借鉴，使他开始以画面的"自然空间"转向"文化空间"，运用西方基督文化中某些图式因素，创作了《后古典系列》。如其中的《大悲爱的复归》（见本报今年23期），即沿用他在《凝固的北方极地》中创造的人物造型，把伦勃朗的《浪子回头》发展成两组重复的形象。"由此所创造出的图式，是为了使更多的心灵能够感知到，在人类文化史中（我主要指西方文化）存在有一种健康向上的崇高的力"（王广义）。这种庄严的静穆，就是对于中国文化中空灵虚静的超越。同是静，虚静的静在对象个现实社会的逃避中，个人躲遁于自然风光而获得的宁静，而静穆是关注"人类整一日的向上的精神""进入水冰洁白的艺术观照时所体验到的庄严与躁动"（王广义语）。

由此我们看到他们对一种新的文化心态的追求，而这得之于在更广泛的文化范围上的借鉴，同时，对传统的选择也获得了一种新的意义，再不是在一个封闭的文化体系内部的寻租和自我循环了。

（思潮版编者）

●思潮版编辑●栗宪庭●

A page from *Zhongguo Meishu Bao* (Fine Arts in China), no. 39, September 1987

painting to promote the spread of the Christian doctrine; Wang Guangyi changed this into an intellectual schema for the creation of his utopian rational world.

The *Frozen North Pole* series concluded the artist's attempts at playing God's spokesman through modernist methods. The most studied artistic movements of the time, whether they were anti-rationalist like Romanticism and Expressionism, or rationalist like Cubism and Abstractionism, could not attract his interest. He was a devoted apostle, trudging forth unwaveringly on his road to construct a mysterious spiritual kingdom.

As Nietzsche wrote: "the world as a work of art that gives birth to itself".[35]

But a year later, a new cognitive stimulus changed Wang Guangyi's artistic direction.

Image Correction: A Revelation

In the mid-1980s, while the Chinese avant-garde art movement was gaining momentum, an art theory translation project was underway at the Zhejiang Academy of Fine Arts where Wang was a student. This academic project, led by Fan Jingzhong, did not have any direct connections to this art movement; its criticism of the movement's views on Hegelian determinism and its various anti-rational currents made it, in fact, stand in firm opposition to the movement. A posteriori, however, it is possible to state that this project provided a vaster and more meaningful set of theoretical resources for the progress of contemporary Chinese art.

From its first volume, published in 1984, Fan Jingzhong's *Meishu Yicong* (Fine Art Translation Series) began systematically compiling and translating Western art history and critical theory. The first volume, issued in 1985, included a chapter on ancient Greek art from E. H. Gombrich's *Story of Art*, as well as one of Gombrich's important treatises on the relationship between Renaissance art theories and landscape painting; furthermore, it contained an excerpt from Lin Xi's translation of Gombrich's important work *Art and Illusion* (the full translation of which would be published two years later). This short excerpt, titled "On the Representation of Art", was, understandably, unable to attract the interest of Wang Guangyi, who was immersed in the dynamic artist group to which he belonged. Two years later, however, in an article on Wang Guangyi that appeared in the new wave publication *Zhongguo Meishu Bao* (Fine Arts in China), we surprisingly see this statement: "[I recently] read some books by Nietzsche and Gombrich. Nietzsche taught me how to extract myself from the difficult situations around me, while Gombrich gave me inspiration regarding schemata – on their cultural correction and continuity".[36]

Most scholars, including perhaps the artist himself, probably never attributed much value to this offhand remark, viewing it, at most, as the combination of theories dear to the artist; just think of his combined application of Hegel and Nietzsche. But considering the great change in Guangyi's artistic projects, we can establish a speculative connection between Gombrich's theories on schema and correction and the artist's work, similar to Gombrich's speculative link between *The Birth of Venus* and neo-Platonism in *Botticelli's Mythologies*.

Art and Illusion takes on a fundamental theoretical question in Western art history: how the cognitive and perceptive processes have influenced the history of the world's visual representation through image production. This question, rooted in Plato's two worlds theory, is critically inseparable from an investigation

119

Fan Jingzhong with E. H. Gombrich and his wife in the UK, 1996
Photo Yang Siliang

The Chinese version of *Art and Illusion* by E. H. Gombrich, translated by Fan Jingzhong, 1987

of Western art history. On the foundation of Karl Popper's searchlight theory in his writings on the philosophy of science, and the falsifiability principle of scientific verification, Gombrich established his theory of schema and correction. This makes use of philosophy, cultural studies, modern psychology and art history in order to comprehensively respond to this classic question of modern art theory. The excerpt of *Art and Illusion* translated by Lin Xi clearly and concisely explains Gombrich's position. It begins by verifying the process by which perception is a preliminary correction. We can only correct and revise what we see on the basis of a series of initial schemata (our mental orientation) in certain perceptive situations. There is no neutral naturalism, nor is there a so-called "pure eye". No artistic creation or act of visual perception can escape this common rational principle. All artistic language is, in essence, conceptual: "Without some starting point, some initial schema, we could never get hold of the flux of experience".[37] A "correct" image is, like a map, the result of a long process of schema correction. The dilemma posed by Plato regarding the relationship of falsity that exists between ideal forms and their imitations had artistic significance solely within the long history of image production. According to Cassirer's principle that human existence is inseparable from the production of symbols, man's world is not merely physical; when there is no difference between true and false, man's world is a world of signs. The production of signs always follows "making before matching, creation before reference": that's why this very process is our context for experiencing the world.[38]

In Karl Popper's theory of falsification, the scientific process of hypothesis and falsification is determined by "situational logic". Popper's famous political philosophy treatise *The Poverty of Historicism* replaces Hegel's historical determinism. Gombrich inserts this theory within his reflections on art and cultural history. He incorporates the concepts of the pressures of fashions and the mysteries of taste into his schema and correction principle, which he uses for analysing artwork. He coins the syntagma "ecology of the image" to describe the effect of this principle on the history of representation, and gives the name "vanity fair" to the changed situational logic within the historic artistic realm, thus bestowing it with a historic-cultural significance that surpasses the psychology of the form.[39]

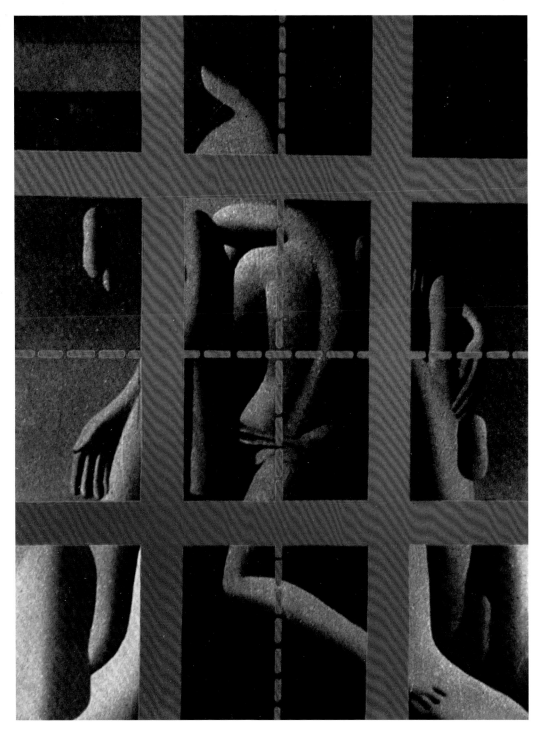

Wang Guangyi,
Red Rationality: Pietà, 1987
Oil on canvas, 200 x 150 cm (78³/₄ x 59 in.)
Collection of the artist, Beijing, China

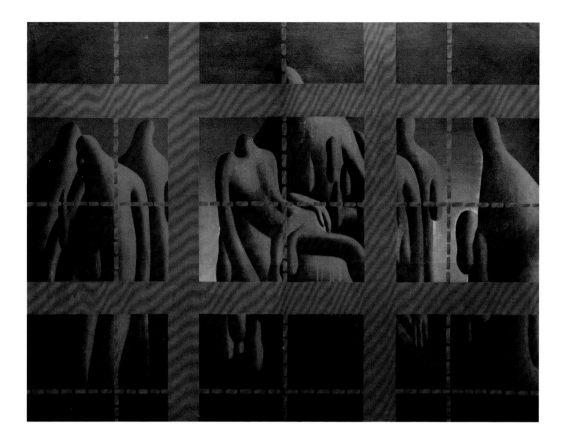

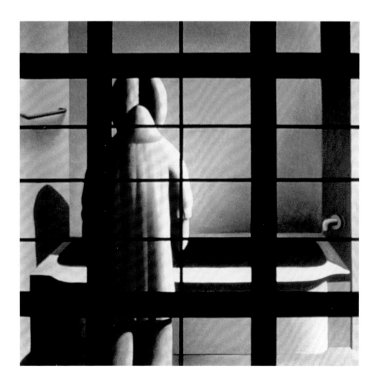

Wang Guangyi,
*Red Rationality:
Revision of Idols*, 1987
Oil on canvas,
160 x 200 cm
(63 x 78³/₄ in.)
Collection of the artist,
Beijing, China

Wang Guangyi,
*Black Rationality:
White Toilet*, 1987
Oil on canvas,
150 x 150 cm
(59 x 59 in.)

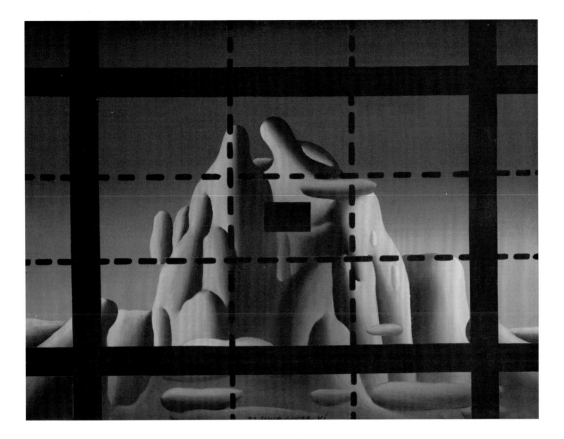

Wang Guangyi,
*Black Rationality:
Purgatory Analysis A*,
1987
Oil on canvas,
79 x 103 cm
(31¹/₈ x 51¹/₈ in.)
Collection of Sun
Yujing, Chengdu, China

Wang Guangyi's interest in this theory was certainly connected to his dismissive attitude towards the "retinal games" of the Impressionists. He perhaps found theoretical backing for his own artistic tastes within Gombrich's critique of the pure eye, but it is just as important to consider that the situational changes within the group forced each participant to seek out new theoretical resources to defend their status within the group itself. The neo-Platonic mystical imaginary of *Frozen North Pole* was increasingly unable to make the cultural waves that the artist had hoped for, and even began to seem not unlike the overly-philosophized art forms that everyone had begun to disdain. Furthermore, the need for the movement to become more competitive placed this seemingly native religious form of painting on the margins of the art trends of the time. Mapping out a new artistic plan while maintaining his own theology, which would set him apart from the movement from which he had come, became Wang Guangyi's main challenge.

It is certainly difficult to reconstruct the artist's specific process of reading and interpreting Gombrich's theory, but, in his sustained exchanges with Hong Zaixin and Yan Shanchun, two important researchers in Fan Jingzhong's academic group (who were also Wang Guangyi's earliest scholars and interpreters), we can see the way in which the artist adjusted his own ideas in an effort to balance a redefinition of his artistic plans and the persistence of his theological beliefs. This theory was, in the artist's own words, at least "revelatory" in his artistic reformation. In an open letter from Hong Zaixin, we can see an art historian's sincere evaluation and critique of Wang Guangyi's work. Hong Zaixin's

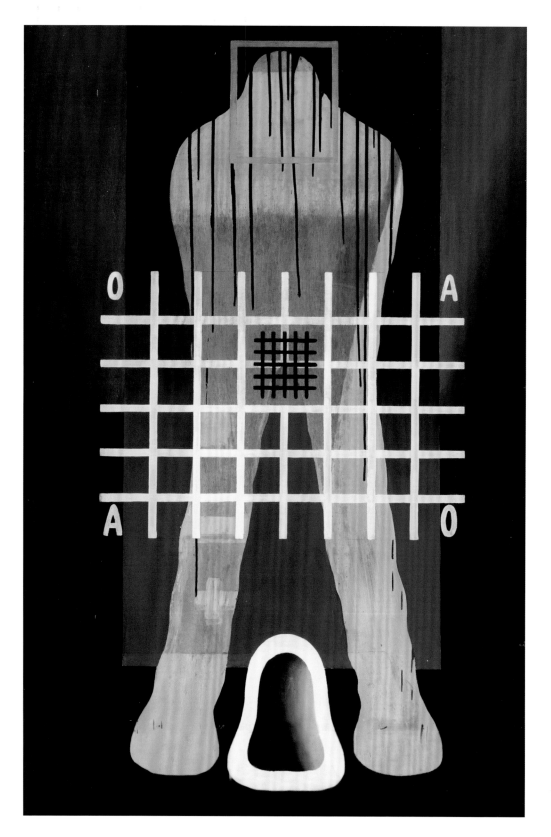

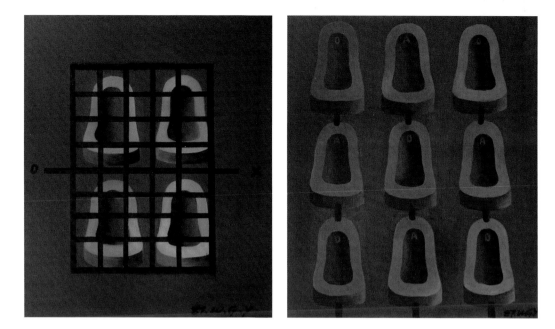

words touch not only on issues of art, but also of mass communication and in-formation. His critique of the closed cultural attitude that comes out of Wang Guangyi's art clearly expresses dissatisfaction with the theological leanings of Hegel, warning that it leads to a "new religious spirit" embellished with trappings of cultural authoritarianism.[40] The scope of the discussion broadens in numerous letters to Yan Shanchun. In one long letter regarding his artistic language, Wang Guangyi provides a new reading of the concept of schema, proving that the question of language becomes a direct motive for formulating his new artistic goals:

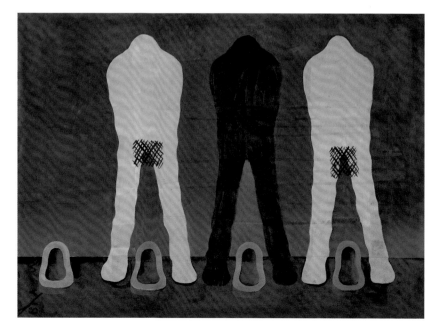

I think that, based on past art history and the state of today's art, we can split the language of painting into two levels: technique and schema. Generally, starting from this point, we can basically create a clear outline of art history: technique references the models and materials that the artist employs; schema references the standardization of certain elements (shape, light and shadow, space), and is somewhat more fundamental and stable than style. In terms of the history of style in Western painting, it reached its first peak with Van Eyck, and later with Rembrandt and Velázquez. But in modern painting, technique is not as important as schema. Impressionists such as Manet and Monet were not as exacting as classicalists such as Ingres, or the romanticist Delacroix. Certain abstract painters such as Kandinsky and Mondrian cannot even compare to the Impressionist painters. Of course, this is all relative. During the age of the Abstract Expressionist painters (such as Zao Wou-ki), they all placed great importance on the production of the overall image. But the focus on schema, even the conscious diminishing of the structural effects and subtle emotional changes tied to the depiction in order to emphasize the uniqueness and immediacy of the schema itself, is a fundamental characteristic of modern painting. In this sense, the language of contemporary art is more symbolic. Of course, this is not to imply that the presence of a schema means that one can create randomly, but it emphasizes that technical skill must follow the schema. What do you say? It sounds strange to say it, but once we have accepted these principles of modern art, it is not hard to imagine how strange it would be to use the techniques of Van Eyck or Rembrandt to produce a Mondrian painting.[41]

The *Post-Classical* series created in the second half of 1986 was an important transition for the artist's schema-correction plan. The goal was to create a captivating schema of reference to establish a separation from all modern language experimentation and to assist him in resolving the religious question that had perplexed him all these years. He chose a series of images from the Renaissance and neo-classical iconography as the subject of his corrections; in this way, the schema and correction principle that Gombrich applied in representational analysis was intentionally misread by the artist as an innovative linguistic method, which he further altered so that it could become a competitive instrument for creating new art. *Post-Classical: the Death of Marat* was the first work in this series. As in *Frozen North Pole*, he begins by geometrically rendering the human form and multiplying it into symmetrical twin images. Thus the real event and person are transformed into an allegorical personification, and the neo-classical work of art is stripped of any non-essential detail or contextual element; in this way the artist refines the aura and neo-classical solemnity through figurative depiction. In a series of artworks derived from biblical themes, such as *Post-Classical: Zenith – Sacred Supper*, *Post-Classical: Simultaneous Annunciation*, *Post-Classical: Gospel of Matthew* and *Post-Classical: Return of the Prodigal Son*, he used the same corrective techniques.

This religious subject matter did not show that the artist was a Christian in the true sense, nor even a practitioner of modern liberal Christian thought. Though he often pondered Saint Augustine's thoughts on creation in *Confessions*, ruminated on Aristotle's sense of order and the "material spirit" in Aquinas's theological logic, and though he liked to draw from the sayings in the Old and New Testament to express certain revelations, for Wang Guangyi these sacred images only represented transcendental models to apply to his corrections and schemata. What links these works is the fact that he used the theological content of a master's artwork and reshaped it into forms devoid of the context of their spe-

Wang Guangyi,
Quick-Drying Industrial Paint, 1989
Industrial paint on print, 30 x 22 cm (11³/₄ x 8⁵/₈ in.)
Collection of the artist, Beijing, China

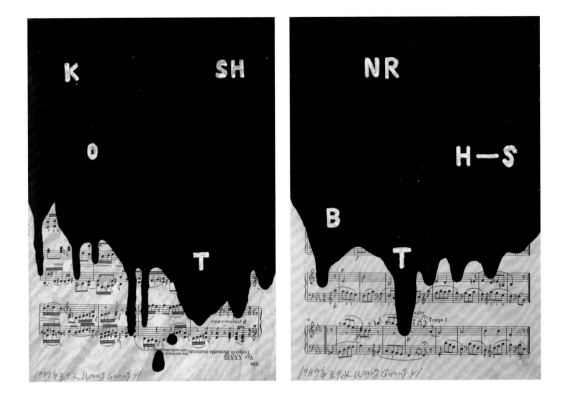

cific stories in order to create a subtle tension between the theological themes and contemporary linguistic experimentation. He later frankly admitted, "My *Post-Classical* series, to a great extent, was a test to measure the affect of this mythology on people's appreciation of art".[42]

The theological objective of the images in *Post-Classical* was the same as that of *Frozen North Pole*, but since he employed the technique of correction to existing classical images, it gave his work a more cognitive foundation, and eliminated the cultural emotional emptiness and the presumed theological issues of the previous series. A similar analytic attitude could have easily transformed the theological questions into specific linguistic questions, opening up a pathway for his next artistic strategy: the use of ready-mades. As he later summed up, "The artist can have God in his heart, but when he is searching for God, he should maintain a high level of intellectual concentration and attentiveness in handling technique and its trivialities".[43]

Between 1986 and 1987, the artist created the *Post-Classical* and *Rationality* series in Zhuhai, far from the epicentres of artistic activity. According to the "logical progression" – an art term that Wang coined during this period – of *Post-Classical* and *Frozen North Pole*, the works must not only reference his past creations, they must also possess an internal logic that connects them to all of art history:

> I think that aside from being familiar with the art history of the past, an artist must also accurately grasp the position and significance of art in contemporary culture. From this perspective, we can distinguish two types of artists: good artists and meaningful artists.[44]

Wang Guangyi,
*Famous Tunes
Covered with Quick-
Drying Industrial Paint*,
1989
Industrial paint on print,
10 pieces, 29 x 21 cm
(11³/₈ x 8¹/₄ in.) each
Collection of the artist,
Beijing, China

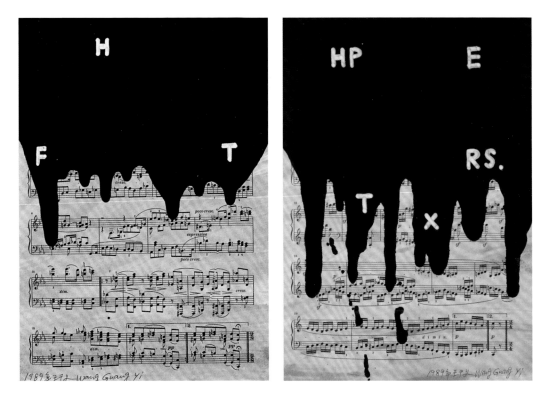

He clearly defined the duties of these two types of artist: the former is mainly tasked with experimenting with various linguistic styles, while the latter uses particular schemata to pose relevant cultural questions. The *Rationality* series can be understood as the technique of an artist who is determined to have a meaningful impact. If we say that during the *Frozen North Pole* period, the terms idea and rationality were theological concepts connected to absolute spirit and eternal order, to use the artist's vocabulary, then the use of the term "rationality", when applied to art, referenced an empirical practice tied to cognitive concepts such as analysis and correction as well as concepts linked to historical context like test and taste. This does not imply that Wang Guangyi had discarded his interest in the transcendental world. Within the competition for fame typical of the current art world, he was keenly aware that transcendental questions could only truly be resolved when placed within the limits of the empirical world, within various secular contexts and within fashion. Neo-Platonist meditations and Nietzschean assumptions could only simplify the problem. The appreciation of myths and the making of idols are the two indispensable elements for competition and the value system of modern art. If the various competing linguistic experimentations lack mythological and mystical foundations, they will never be capable of affecting cultural history, and this is the artistic value most important to Wang Guangyi.

The corrections in the *Post-Classical* series became schematically simplified and antiformalist; grids, dotted lines and letters were placed on top of the schema previously developed in *Post-Classical*. In fact, the dotted lines and letters had already emerged in *Post-Classical: Madonna and Child* (aka *The Trinity*), *Post-Classical: Big Doll – Madonna and Child* and *Post-Classical: After Mona*

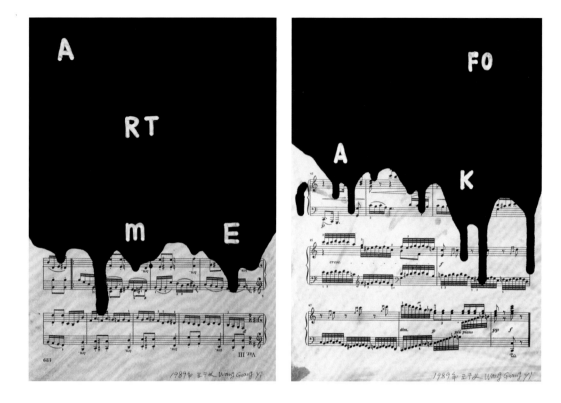

Lisa. These signs were perhaps a reference to Pythagoras's mathematical logic; together with the geometrically rendered figures, they compose a kind of mystical metaphor. In the *Rationality* series, however, the selection of images to correct was no longer limited to biblical themes. Aside from *Red Rationality: Idol Revision*, *Red Rationality: Big Angel* and *Red Rationality: Mourning Jesus*, he also used a large number of pagan themes, as evidenced by his correction of Botticelli's *Birth of Venus*, entitled *Three Sections of Human Body*, his correction of Giorgio de Chirico's *Raft of the Medusa*, entitled *Red Rationality: Analysis of Purgatory*, his corrections of Duchamp's *Fountain*, entitled *Nine Duchamp Urinals* and *Four Duchamp Urinals*, and even his correction of his own early work *The Back of Humanity*, entitled *Black Rationality: White Bathroom*.

His image rendering methods not only demonstrate that the realm of the correction of schema had expanded to cover all of art history, they also show that his artistic tastes had developed from an innocent pursuit of the sublime and the harmonious to more diverse directions. In *Rationality in Common Behaviour* and *Three Sections of Human Body*, he shows he has acquired humorous, satirical and mocking methods to discuss the issues brought up by the images. From another perspective, the series demonstrates the artist's intention to create an international version of his work (he expressed this wish in many discussions with his friends during this period, and it became an important part of his artistic choices). This conceptual-stylistic method of the image correction gave Wang Guangyi the desire to create a deviation from the semiotic meaning of the image, and this deficit of meaning would allow him to obtain a suspension of aesthetic judgement from his audience. In a later explanation, he further bestowed these conceptual signs with religious import:

Wang Guangyi,
Famous Tunes Covered with Quick-Drying Industrial Paint,
1989
Industrial paint on print,
10 pieces, 29 x 21 cm
(11³/₈ x 8¹/₄ in.) each
Collection of the artist,
Beijing, China

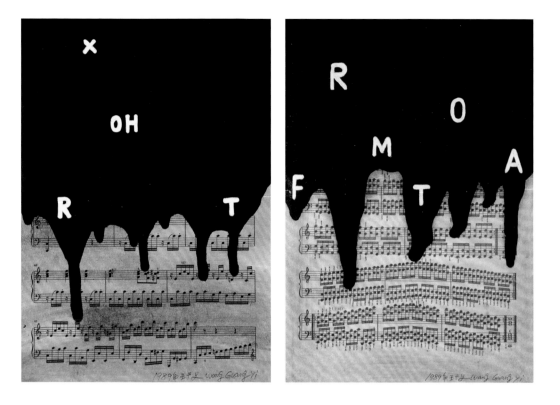

In a certain sense, my later use of grids on the canvas was connected to the views I had back then. The grid is a kind of visual order; it gives order to our perceptions. This brings order to our lives, and through this order, we can verify the existence of God. … My understanding of order and proportions of form was entirely built on a foundation of the sacred and the unknown. That is to say, I placed the grid on the canvas to obtain a kind of order in the vision of others. Such order is merely a principle of rationality. It aspires to the formalism that was prevalent at the time.[45]

Such an explanation is perhaps only meaningful when placed within the following contradictory logic: the artist's maintenance of faith in the transcendental world and simultaneous participation in the competition within the contemporary art world would make him capable of safeguarding the two antithetical objectives only if he could perfectly balance the relationship between the language and images he was manipulating.

Wang Guangyi had to draw from a new cognitive method to explain his route from the *Post-Classical* to the *Rationality* series. In *Symbolic Images*, Gombrich distinguishes between two different literary and pictorial mythological traditions in the West: the tradition of mystical symbolism and that of metaphorical symbolism – the former referencing neo-Platonism and the latter referencing Aristotelian rationalism:

What I have called the Aristotelian tradition to which both Caro and Ripa belong is in fact based on the theory of the metaphor and aims, with its aid, to arrive at what might be called a method of visual definition. We learn about solitude by studying its associations. The other tradition, which I have called the neo-Platonic or

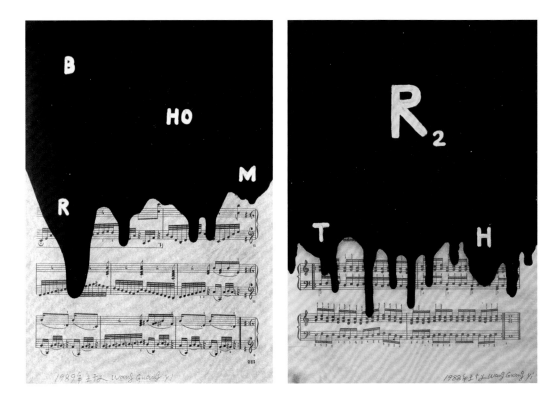

mystical interpretation of symbolism, is even more radically opposed to the idea of a conventional sign language. For in this tradition the meaning of a sign is not something derived from agreement, it is hidden there for those who know how to seek. In this conception, which ultimately derives from religion rather than from human communication, the symbol is seen as the mysterious language of the divine.[46]

Wang Guangyi,
Famous Tunes Covered with Quick-Drying Industrial Paint,
1989
Industrial paint on print,
10 pieces, 29 x 21 cm
(11 3/8 x 8 1/4 in.) each
Collection of the artist,
Beijing, China

Gombrich pointed out the merits and defects of both traditions: the metaphoric symbolism, owing to its overemphasis on the linguistic power of a limited conventional system, forgets the elevated resilience and vitality of language. The mystic symbolism, because of an overemphasis on the irrational, brings with it the danger of falling into an arrogant vacuousness or a banality masking as depth.[47]

These two traditions not only had a profound impact on classical art, but on modern art as well, with the various currents of Romanticism, Expressionism and Abstractionism connected to the tradition of mystical signs, and Surrealism, Cubism, Symbolism and the metaphysical schools linked by various affinities for metaphorical symbolism. If *Frozen North Pole* represents the pictorial tradition of mystical symbolism in Wang Guangyi's art, then the *Post-Classical* and *Rationality* series represent a shift towards the rational pictorial tradition of the metaphor. Of course, the artist intentionally created contradictions in the *Post-Classical* and *Rationality* series: those dotted lines, letters and grids interact with the image in a relationship of both refutation and affirmation, providing the images with a sort of paradoxical duality – they are both mystical (Mondrian-esque) and rationalist (Poussin-esque), embodying the meeting ground of each one's respective objectives. Understanding this transformation and its nature is crucial for understanding the evolving logic of Wang Guangyi's art.

In an important discussion with Yan Shanchun in 1991, Wang Guangyi was already able to deftly employ Gombrich's methods and tone to talk about all kinds of questions related to art. This document is important for understanding Wang Guangyi's thoughts and the ways in which they would later evolve. Reflections stemming from the two linguistic methods illustrated by Gombrich are the focal point of the discussion:

> My *Post-Classical* series to a great extent tests the effect of the myth on people's appreciation of art. I think that the reason that the *Post-Classical* series has been accepted by many critics and artists is largely thanks to its mythological implications. It demonstrates to us that we cannot escape the effect of the traditions shaped by myth on our ability to appreciate art. When I was studying at the Zhejiang Academy of Fine Arts, I imitated the styles of all of the various schools, but I could never quite understand why I found classical art more enchanting. After graduation, I made *Frozen North Pole*, trying to use my own vocabulary to express that "sense of the sublime". Though the critical response at the time was rather positive, I still felt that something was missing. Later, I slowly came to understand why I had been so infatuated with Western classical art. I used schemata that were known and accessible to me and subjected them to a constant process of correction and modification in order to evidence the original text of the myth in the broadest way without losing its implications for modernity. … Perhaps such myths are essential to people's appreciation of art, but when an artist lifts his brush and faces the canvas, he should wash away this way of thinking. This is even more the case for the contemporary artist. He should first perceive and analyse the specific cultural atmosphere of his surrounding social environment, or more simply, feel out the situation, and deduce which kind of schema can produce a "mythological effect", or become a part of the cultural fabric. The contemporary artist must have a magic eye, clear ideas and a passion for the world. … I think that my *Post-Classical* series is more of an embodiment of the historical views of a contemporary cultural revisionist. Many people deride us artists or the critics for our propensity to create myths, but myth creation is actually quite uncommon. Think about how bland life would be without myths. The world would be cold and hard like an iron plate. In recent years, I have understood the significance of myths in life, and have tried to place them in an appropriate position. … Overall, contemporary art should primarily push for aesthetics – because aesthetics emerge under the aegis of art – and then suppress this impulse, because aesthetics strive to bring art back into life. One could say that it is a very enticing psychological trap. I personally feel that we can apply Popper's and Gombrich's situational logic to test the validity of this idea. I think that modern art is still heavily marked by mysticism. Spiritually speaking, it points to an "absolute". The works of Kandinsky and Mondrian are artistic equivalents of the philosophy of Plato and Hegel. They became transitional figures between modern and contemporary art precisely because they pushed this question to its extreme. Duchamp, on the other hand, completely escaped the influence of Hegelian thought in art. He discovered that the mysticism in art was problematic, and starting from this, experimented with a series of ideas. Duchamp's influence is profound. In the 1960s and 1970s, many of the most significant artists in the world accepted his thesis. His works have powerful analytical import. Duchamp discovered an infinite plot of untouched soil for future generations. He was acutely aware of his situational logic.[48]

Wang Guangyi's encounter with Gombrich's thought perhaps did not fundamentally alter the neo-Platonic/Hegelian theological objectives of his art. We discover that after 1988, however, he rarely used empty and dark leaning formula-

Entrance to Beijing's Forbidden City, 1949

tions [this is a reference to Xuanxue, the Neo-Daoist school of thought often mis-leadingly translated as "Chinese metaphysics". *Translator's note*] such as the ab-solute spirit or ultimate essence, replacing them instead with such terms as mys-tical entities and mythic effect, demonstrating more precise and broader refer-ences in his theological system. Nevertheless, this encounter with Gombrich strengthened his analytical abilities and sensitivity in grasping problems regard-ing specific cultural situations; this ensured him a significant intellectual, cogni-tive and creative advantage in the artistic competitions he would later face. At this point, we already see indications of a transition from a Nietzschean superman artist to a contemporary artist marked by his ability to be both deliberative and open.

Mao Zedong: AO

The importance of the 1988 work *Mao Zedong: AO* in Wang Guangyi's artistic evolution cannot be overstated. It essentially contained all of the requirements nec-essary to enter into contemporary art history: from a personal perspective, and with acute awareness, the work expressed a problem using unique language; it depicted an image that was chosen with extreme sensitivity and which was open to interpretation and multiple readings; and it had a "mythical" story behind it due to various specific circumstances and a series of serendipitous events (the idea, its presentation, release and auctioning). Finally, and most importantly, was the intricate relationship between the painting and Wang's own artistic logic. These elements are enough to turn the work into a subject of ample interpretation.

 Looking at the documentation, beginning as early as 1988, the "con-temporary question" is at the centre of Wang Guangyi's thought. This question is

crucial to the logical progression of his art in at least two ways. First, compared to modern Chinese culture, contemporary culture is a material culture tied to instant gratification, atheism and a refusal of critical enlightenment rationalism. At the same time the culture worships mass communication, immediate results and the myth of capital. Second, compared to the artist's experience of modern Chinese history, contemporary culture is open to democracy, the free market and true internationalization, but is also a fetish culture, a highly organized and centralized culture whose teleological structures are shared by virtue of the centralized materialist education. According to Wang Guangyi, though this culture is incompatible with his faith, it is full of contradictions between the transcendental world and the empirical world, and as such still needs divine inspiration. Elaborating on Gombrich's concept of schema and correction and Popper's situational logic, Wang Guangyi quickly distanced himself from every atheist and materialist theology, and re-established his position in contemporary art. By this time he knew that only an enlivened artist possessing a disinterested faith could win in this cultural game.

In a 1989 interview in *Hualang* (Gallery) magazine with the Nietzsche-inspired title "Wang Guangyi Says", the artist described the metamorphosis of his artistic vision for the first time, dividing it into three phases beginning in 1985: 1985–86 was the first phase in which he rebuilt his wavering faith. This phase brought out his noble humanist spirit. The second phase spanned from the end of 1986 to 1987 and involved applying corrections to art history. The third phase (from 1988 to 1989) involved "stripping away the 'flood of meaning' brought about by the illogical nature of humanist passions". He explained that the third phase was a self-imposed elimination of the "meaningless hypotheses" of the previous two phases, because he grew aware that "the essence of contemporary art is blind to meaning; gathering the essence of such art is based on an analytical linguistic approach. Only artwork possessing obscure areas in meaning would push the judgement of the contemporary man to its limit". When he was asked whether or not changing his cultural beliefs had turned him into a nihilist he responded negatively, emphasizing that he was an artist who still relied on "spiritual self-sufficiency" to live and to create.[49]

In an interview in *Yishu Guangjiao* (Wide Angle on Art) that same year, he returned to this issue using an anthropological tone and rare poetic language. As he saw it, humans had also undergone three phases throughout their existence: first, man was unable to conceptualize, and lived in harmony with the animals; in the second phase man formulated hypotheses about faith and began to exist in conceptual terms and feel a sense of emptiness caused by the loss of paradise: man thus began his eternal pursuit of the infinite, creating entities and objectives beyond the human; the third phase was man's disappearance, every empirical trace of man as a class was lost. During this phase, the elevated spirit would no longer be a problem: "The most significant thing we must do now is to grasp onto every meaningful experience, to experience them in our skin and describe them so as to reject mankind's commonality". He believed that not only was culture unable to save this process of disappearance, it would actually accelerate it:

> The aim of culture is to turn man into a conceptual man, rather than into a concrete man. The only thing that can delay this process is the power of passion and love. Whoever possesses these abilities can save himself. When a pair of weakened hands touches an object of youth, a miracle occurs! From the desolate with-

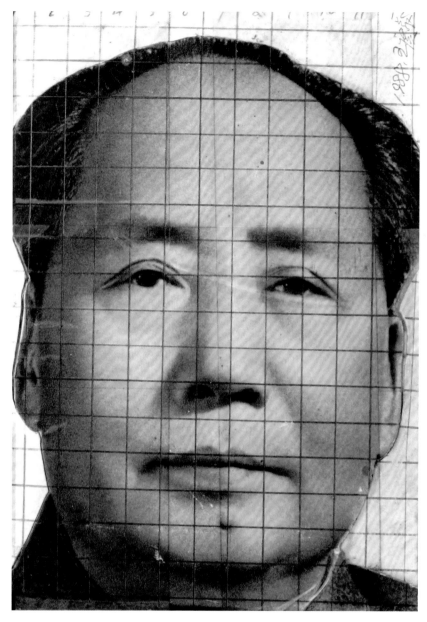

right
Wang Guangyi,
study for *Mao Zedong
AO*, 1988
Ink and oil on
embroidery,
120 x 80 cm
(47^1/$_4$ x 31^1/$_2$ in.)
Collection of the artist,
Beijing, China

Wang Guangyi,
study for *Mao Zedong: AO*, 1988
Ink and ball-pen on print from magazine,
35 x 27 cm (13^3/$_4$ x 10^5/$_8$ in.)
Private collection, Guangzhou, China

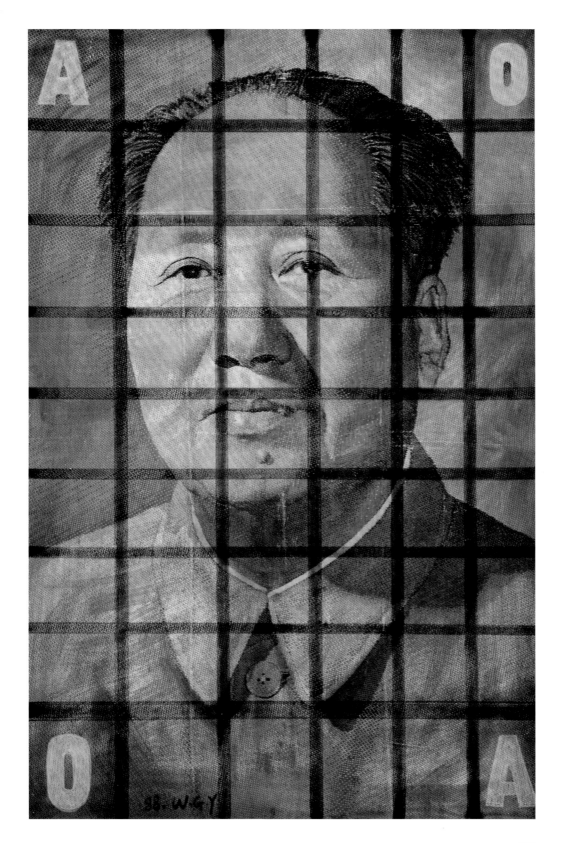

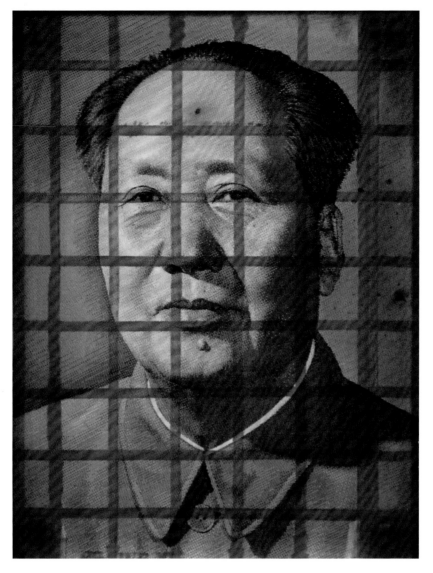

Wang Guangyi,
Mao Zedong, 1988
Ink and oil on
embroidery, 35 x 27 cm
(13³/₄ x 10⁵/₈ in.)
Collection of the artist,
Beijing, China

ering wastelands emerges the song of youthful optimism and the joyous laughter of children.[50]

But neither this pessimistic cultural judgement nor the questioning of his own art would turn the artist into a total nihilist. This is a phase that the artist called the "separation from the self":

> Artistic creation is a process of constantly replacing spiritual hypotheses – by suppressing one, the definition of another emerges. In this process the only thing to persist is the illusory point of reference undergoing this dynamic process. The greatness and shortcomings of man, the nobility and absurdity of a model are all deduced through the existent self and the imagined self. The tragedy of man is that he is a dethroned god. His divine nature disappeared long ago, and now his humanity is beginning to disappear. We should concentrate on the great ground-

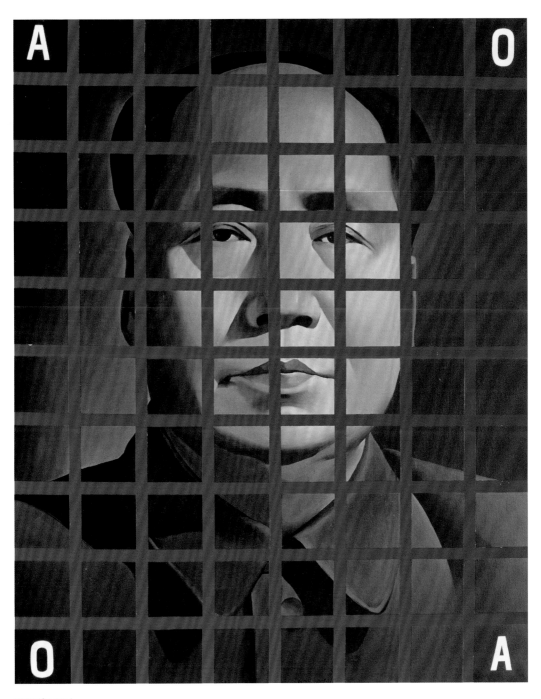

Wang Guangyi,
Mao Zedong: Red Squares No. 1, 1988
Oil on canvas, 150 x 130 cm (59 x 51$\frac{1}{8}$ in.)
Minsheng Art Museum, Shanghai, China

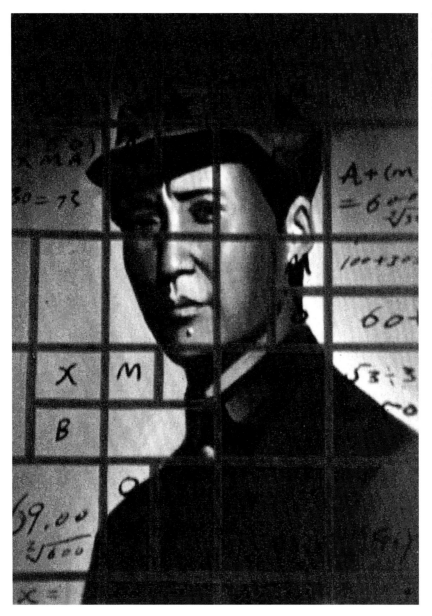

Wang Guangyi,
*Mao Zedong in the
Yan'an Period*, 1988
Oil on canvas,
86 x 68 cm
(33^7/$_8$ x 26^3/$_4$ in.)
Private collection,
Beijing, China

less and hypothetical memory of our past divinity and our disappearing human-
ity! In this way, many of man's useless passions can be set ablaze between the
two selves; this is the only happiness that today's man can enjoy.[51]

Is this apostolic speech the psychological basis for *Mao Zedong: AO*? Is the work
a "great, groundless, and hypothetical memory"? What kind of logical connec-
tion is there between this "hypothetical memory" and the artist's controversial sup-
pression of humanist passions?

The sketch for *Mao Zedong: AO* was presented in November 1988 at
the Huangshan Modern Art Conference, during which the artist declared his in-
tention to remove the humanist passions from his work. *Mao Zedong: AO* was

Wang Guangyi,
Waving Mao Zedong: A,
1988
Ink, ball-pen and oil on
print from magazine,
22 x 21 cm (8⁵/₈ x 8¹/₄ in.)
Collection of the artist,
Beijing, China

Wang Guangyi,
Waving Mao Zedong: B,
1988
Ink, ball-pen and oil on
print from magazine,
26 x 23 cm (10¹/₄ x 9 in.)
Collection of the artist,
Beijing, China

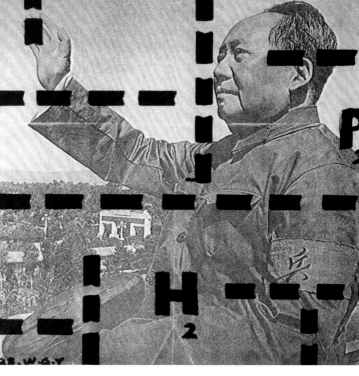

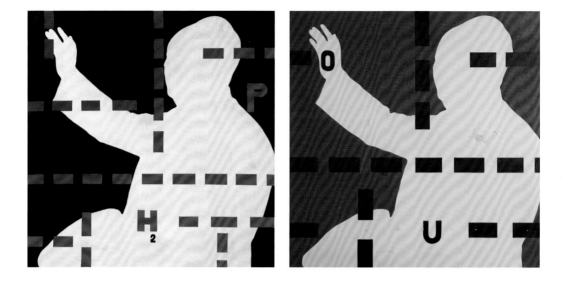

officially exhibited in February of the next year at the *China Avant-Garde Exhibition*, eliciting an enormous response, as evidenced by its publication in *Time* magazine. At an interview for *Beijing Qingnian Bao* (Beijing Youth Daily) during the exhibition, Wang Guangyi once again emphasized his position: "My main commitment will be to remove the problems caused in art by the illogical nature of humanist passions". According to one researcher, "No matter what, in the first half of 1989, 'clearing out of humanist passions' was a front-page slogan, known throughout the Chinese art world".[52] But it wasn't until October 1990 that Wang clearly elucidated his position in an essay written for *Jiangsu Huakan* (Jiangsu Pictorial). This essay, entitled "On the Clearing out of Humanist Passions", began by delineating between classical, modern and contemporary art, and explained that this "clearing out" was aimed at the origins of the classical and modern artistic language, and its "mythological history founded on illusory empirical facts". Contemporary art, according to Wang Guangyi, should eliminate this "mythical sense of illusion" and the dependence on humanist passions, and "solve questions related to art by using a linguistic background marked by an explicit logic based empirically on the cultural events of the past". The unresolved problems of classical and modern art would thus be the starting point for his future work. After reflecting on his creative experience under the mythical aura of his two previous phases, he delineated two "mythological tendencies" in art which also mark the boundary between two types of art practice: the creation of meaning influenced by humanist passions and devoid of educational worth, and the logical solution of problems stemming from mythology. After declaring that his own artistic work would attempt to resolve the many questions linked to culture, he wrote, emotionally:

> At the same time, I am also profoundly aware that to be able to remain within the myth and peacefully carry out work in the classical and modern sense is a happy condition. There certainly is something against human nature about the desire to enter into the specialized field of research that attempts to take on and resolve residual cultural questions. In this way, we can understand why contemporary artists as Beuys would sometimes like to return to the kingdom of mythology.[53]

Wang Guangyi,
Hand-waving Mao Zedong with Red Dotted Lines, 1989
Oil on canvas,
100 x 100 cm
(39³/₈ x 39³/₈ in.)

Wang Guangyi,
Mao Zedong: OU (triptych), 1989
Oil on canvas,
100 x 100 cm
(39³/₈ x 39³/₈ in.)

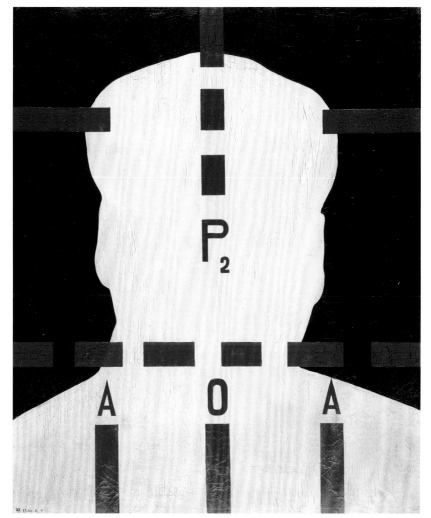

Wang Guangyi,
Mao Zedong: P2, 1989
Oil on canvas,
120 x 100 cm
(47¹/₄ x 39³/₈ in)

These three documents provide an extensive and evaluative context for Guangyi's "clearing out of humanist passions" in terms of anthropology, art history, and the artist's own personal history. This formulation was a product of the pressing influence of recent artistic tendencies and attitudes. We could perhaps, in a rather academic tone, call it an "existential paradox". That important discussion between Wang Guangyi and Yan Shanchun touched on arguments like the effect of stardom, mass communication, international visibility and market production (though that had only just begun), and it is fairly apparent that when compared to this reality, the images created in *Frozen North Pole* and *Post-Classical* appeared quite affected, increasingly empty, lacking in immediacy and unable to attract the public's attention. Though the *Rationality* series, with its analytical trappings, suppressed these empty humanist passions, the classical nature of the subjects depicted made a direct confrontation with real issues impossible. Suppressing or clearing out, however, does not imply eliminating. In his pragmatic reading of Popper and Gombrich's situational logic, Wang Guangyi had understood that in contemporary art raising issues was more important than creating meaning, and the rais-

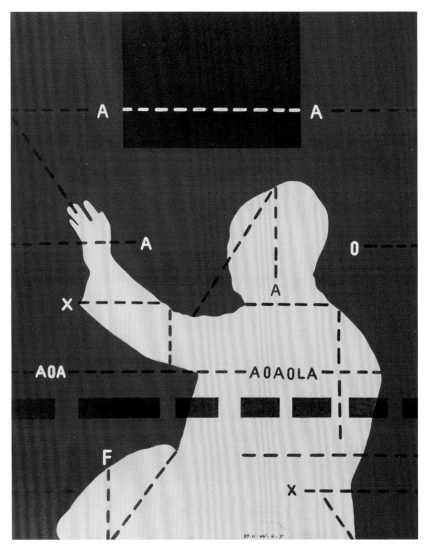

Wang Guangyi,
*Hand-waving Mao
Zedong with Black
Square*, 1989
Oil on canvas,
150 x 120 cm
(59 x 47¹/₄ in.)

ing of issues that were devoid of any emotional leanings was even more impor-
tant (the creation of cloudy areas within meaning). Only when one can truly ask
relevant questions about our culture, questions marked by logic and acuity, and
only when such questions can avoid being stuck in humanistic catharsis can we
truly mobilize the attention of the public, provoke answers and obtain the cultural
effect that a successful artist must know how to guide. Logically resolving issues
of the transcendental world within the confines of the empirical world, and plac-
ing classical art questions such as mythology within a contemporary cognitive
system and explanatory framework is exactly the type of logic that the suppres-
sion of humanist passions expresses.

In the artist's eyes, Mao Zedong is a typical cultural question, a relevant
empirical subject left behind by our historical memory, and *Mao Zedong: AO* is
the result of the linguistic chasteness and logical verification that the artist has
carried out in relation to it. In Chinese modern history, no other leader ever at-
tained the mythical status enjoyed by Mao Zedong (even examples in ancient Chi-

nese history are rare). In the Chinese imaginary there has never been a real distinction between Mao Zedong as a historical figure and Mao Zedong as a mythical icon. Neither the folk movement which aimed to demolish the "temple of the Gods", nor political rational evaluations have done anything to weaken this mythical aura: instead, they have strengthened his image as an anthropomorphic god with human allure, completing the transition from political leader to cultural myth. Wang Guangyi has never hid his profound respect for Mao Zedong. This reverence is not rooted in political faith. To the contrary, it is rooted in reasons that transcend any worldly experience or moral judgement; it is like the Christian faith's triumph over logic. The artist once said that only Mao's utopia made him realize the possibility of a sublime life that transcends the real and material world. Though aware that behind the talent, the dialectic and the posturing there was a certain level of fiction to Mao, Wang Guangyi still believes that Mao holds an irreplaceable psychological significance for the possibility of our transcendence of worldly life and our quest for existential values.

This absolute faith in the historical figure (or cultural icon) was the psychological basis for Wang Guangyi's decision to turn Mao's image into the subject of correction, giving him a completely different cognitive position than previous artists who had treated Mao as an icon of autocracy, and than later artists who treated him as an icon of mass consumerism. For Guangyi, Mao Zedong is the only real world idol who could reconcile the transcendental and empirical worlds, rationality and faith; in this sense *Mao Zedong: AO* is the "great, groundless and hypothetical memory" we mentioned earlier.

Stylistically, *Mao Zedong: AO* is a continuation of the correction methods used in the *Rationality* series, but unlike the geometrized rendering of the classics in that series, the artist uses rigorously realist techniques to reproduce this typical Mao portrait in grey tones; he then overlays it with a grid of equal proportions, marking the four corners of the grid with the letters "AO". In terms of the creation of the image, *Mao Zedong: AO* effectively employs the paradoxical function of a symbolic figure that lies halfway between symbol and representation, between visual sign and conceptual sign, and is capable of transforming the image's original meaning and creating the possibility for multiple readings and interpretations; it is, for all intents and purposes, an open sign.

Let us take a look at how this correction process was completed. First, the realistic portrait of the leader provides a representation of a historical figure that is also, within a certain cultural context, a kind of oracular symbol. It can evoke extrasensory intellectual thought and simultaneously stir emotions tied to the perceivable world, fulfilling the essential theoretical characteristics of neo-Platonic symbolic images.[54] In fact, in China, this symbolic function still effectively exists for portraits of leaders.[55] The grid over the image, however, suspends its original significance. Wang Guangyi calls this suspension the "neutral state", its goal being to halt people's aesthetic judgements and clear out what he considers illogical humanist passions.[56] Conceptual signs made in this manner enter well within the Aristotelian tradition of rational symbols as elaborated by Gombrich. The neutral character of the grid and letters can be understood as a diagrammatic metaphor, or a kind of rational analysis. It is precisely because it uses the tension between the two modes of thought[57] (neo-Platonic mysticism and Aristotelian rationalism) that *Mao Zedong: AO* not only successfully allows viewers to engage in a rigorous political-logical analysis,[58] it also produces a multiplying effect and historical influence on later cultural and artistic developments.

Both scholars and the artist himself view *Mao Zedong: AO* as a transitional work, though their interpretation of the content of this transition may differ. *Mao Zedong: AO* resolved the seemingly intractable contradiction between the artist's faith and contemporaneity. Based on our analysis of the concept and background of the work, it is still a typical example of image correction despite employing a pre-existing and multiplying image (the artist has never provided a serious explanation as to why he chose to make this work a triptych). It is unlike the Pop methods he would later employ, but remains in accordance with the classical aesthetics and techniques of the *Frozen North Pole*, *Post-Classical* and *Rationality* series. The circumstances of its production resemble Johan Huizinga's description of the waning Middle Ages:

> Symbolism was, in fact, played out. Finding symbols and allegories had become a meaningless intellectual pastime, shallow fancifulness resting on a single analogy. The sanctity of the object still gives it some small spiritual value. As soon as the craze of symbolism spreads to profane or simply moral matters, decadence is manifest.[59]

Mao Zedong: AO completed the artist's transformation from a cultural utopian to a contemporary artist capable of grasping the present and facing the most complex artistic questions in the appropriate way.

A Variant Pop

In April 1964, Andy Warhol exhibited a set of *Brillo* boxes at the Stable Gallery on East 74th Street in Manhattan. This seemingly farcical artwork touched a nerve with philosopher and art historian Arthur C. Danto, who began rethinking the philosophical meaning of the essence of art. Twenty years later, he wrote an essay entitled *The End of Art* (and ten years later he would write *After the End of Art*), which used a Hegelian historicist approach to declare the end of art, and assert that art history had entered into a post-historic era (at nearly the same time, German art historian Hans Belting made a very similar assertion). Pop challenged and altered the basic values and standards, the aesthetic logic and the moral references art history had known since the fourteenth century (Hans Belting called this the "history of the image before the era of art"), and was the direct result of a series of continuous modernist experiments. The end implied the disappearance of the internal impulse and the narrative structure that sustained our art history; "one had lost the sense of narrative direction".[60] The manifestation of all this was the destruction of the boundaries between high art and low art, between works of art and ready-mades, and even between artists and non-artists. At this point, the era of artistic aesthetics had come to an end, or, oddly – and as Hegel had predicted in the early nineteenth century – the era of philosophical authority had officially begun. On the one hand, artists had gained unprecedented liberty to do whatever they wanted; on the other hand, there was nothing more to do: aside from declaring that their art was connected to certain philosophical concepts, their creations, in the worst of cases, had nothing to do with art in the lower case.

Whether post-history is a critical judgement or a description of an historical event, this theory of the end of art had a profound impact on the history

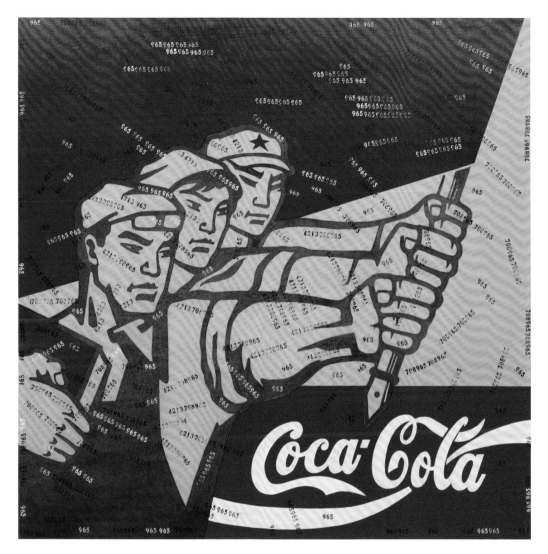

Wang Guangyi,
*Great Criticism:
Coca-Cola*, 1990–93
Oil on canvas,
200 x 200 cm
(78³/₄ x 78³/₄ in.)
Private collection,
New York
Courtesy of AW Asia,
New York

Wang Guangyi,
*Great Criticism: Red
Women's Army*, 2006
Oil on canvas,
120 x 150 cm
(47¹/₄ x 59 in)

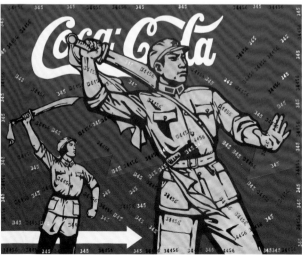

Wang Guangyi,
*The Similarities and Differences of Food Guarantees
Under Two Political Systems*, 1996
Official Chinese propaganda images of hygiene laws,
stones, soil, European food, variable dimensions
Exhibited at *Witnessed: Wang Guangyi*, Littmann
Kulturprojekte, Basel, Switzerland, 1996
Photo Lao Fu

pp. 150–51
Wang Guangyi,
24-hour Food Degeneration Process, 1997
Plexiglas, water, fruits, food and photographs
Exhibited at *In & Out*, LASALLE–SIA College
of the Arts, Singapore, 1997
Photo Lao Fu

of art in the twentieth century, causing art to change and head in directions that are hard to understand. Pop Art, and the Dadaism which came before, brought debates on art back to their Platonic origins (the age-old difference between the object and its copy). They appealed to seemingly radical philosophical devices to raise the level of discourse, but from a technical standpoint they did nothing more than use appropriation techniques to change the foundation upon which classical art depended: symbolism. Appropriation transfigures the meaning, nature and goals of the image by means of the ready-made; often the value attributed to it is both deconstructive and constructive. For instance, according to Arthur C. Danto, this process also has theological import:

> Transfiguration is a religious concept. It means the adoration of the ordinary, as, in its original appearance, in the Gospel of Saint Matthew it meant adoring a man as a god. ... It seems to me now that part of the immense popularity of Pop lay in that fact that it transfigured the things or kinds of things that meant most to people, raising them to the status of subjects of high art.[61]

Jean Baudrillard similarly described the ordinary yet sublime dual nature of Pop Art using the logic of consumption:

> On the one hand, it poses as the ideology of an integrated society ... on the other, it reinstates the whole *sacred process of art*, which destroys its basic objectives. Pop lays claim to be the art of the banal (it is on these grounds that it calls itself "pop[ular]" art), but what is the banal but a metaphysical category, a modern version of the category of the sublime?[62]

Wang Guangyi,
Quarantine – All Food is Potentially Poisonous,
1996
Iron shelves, wooden boards, propaganda images, foodstuffs
Exhibited at *Visual Polity: Another Wang Guangyi*,
OCT Contemporary Art Terminal, He Xiangning Art Museum, Shenzhen, China, 1996
Photo Wang Junyi

right
Jean-Baptiste-Siméon Chardin,
Vegetables for the Soup,
c. 1732
Oil on canvas,
31.7 x 33.9 cm
(12$^1/_2$ x 13$^3/_8$ in.)
Museum of Art, Indianapolis, Indiana

Wang Guangyi,
detail of *Quarantine – All Food is Potentially Poisonous*, 1996

Wang Guangyi,
detail of *Quarantine –
All Food is Potentially
Poisonous*, 1996

left
Wang Guangyi,
detail of *Quarantine –
All Food is Potentially
Poisonous*, 1996

Vincent van Gogh,
Potato Eaters, 1885
Oil on canvas,
82 x 144 cm
(32$^1/_5$ x 56$^5/_8$ in.)
Van Gogh Museum,
Amsterdam

In 1989, Wang Guangyi had created his first ready-made, *Inflammable and Explosive*, in Zhuhai. A year later, in Wuhan, he made his first piece of Pop Art, *Great Criticism: Coca-Cola*. These two works had the markings of a period of change; not only did they position his approach within a contemporary context, they also provoked great misunderstandings in regard to his intentions. Politics and consumption are the main referential spheres to which the majority of interpretations appeal, while we mean to explain them in light of the fundamental conflict between the empirical and transcendental worlds, so as to clarify their internal logic.

Wang Guangyi has emphasized many times that when it comes to his art, revelatory knowledge brought by faith is more important than empirical knowledge (or human knowledge). Within the confines of revelatory knowledge, special revelation (that revelation brought by God) is more important than general revelation (obtained by the observation of nature). According to this logic, his artworks from the 1980s are the fruit of general revelation, rooted in the cognition of common cultural experience. Beginning in the 1990s however, his works have more often been the product of special revelation, stemming from spiritual insights into reality. Though perhaps indirectly, this accords perfectly with the artist's long and winding transition towards contemporaneity.

Actually, *Great Criticism* was not born in a day. Other works in the Pop style, such as *Rembrandt Criticized* and *Mass-Produced Holy Infant* touch on issues connected to his earlier works, while *Great Criticism* was directly rooted within the contemporary context. In an interview, Wang Guangyi once emphasized the inspiration he drew from Andy Warhol and his transformation of ordinary objects into sacred ones:

Andy Warhol mythologized the most ordinary, everyday objects. I used the opposite approach, restoring the human condition to a god (Mao Zedong), but conceptually there is a connection to Andy Warhol. … You could say that beginning with the creation of *Mao Zedong*, I have been concerned with two things: one is myths, and the other is the people. … Western consumer products are tied to a kind of cultural permeability, and this permeability allows for an interesting relationship with the people's conception of it, where two types of mass images from different historical times are magically combined. If you disregard its intellectual content, the visual tension within the image is very complex. As an artist, I only express a certain neutral standpoint.[63]

Wang Guangyi,
The Era of Materialism,
2000
Printed matter, wooden
boxes and food
Exhibited at *Society:
The 2nd Upriver
Gallery Academic
Exhibition*, Upriver
Gallery, Chengdu,
China, 2000
Photo Lao Fu

Perhaps as Wang Guangyi sees it, this Zen-like expressive method that is Pop can extend to his own interest in the transcendental world. What *Great Criticism* is concerned with is precisely this possibility of rendering everyday images sacred.

Andy Warhol's parallel appropriation of ready-made images is a method that strips them of meaning. Unlike Pop in the general sense, the strategy employed in the *Great Criticism* series is an iconographic requisition; its method consists of juxtaposing two semantically divergent images so as to render them paradoxical and generate an opposing meaning, which is not cancelled out, but modified. On the one hand, *Great Criticism* uses manifestic prints from the Cultural Revolution and Western consumerist logos, subjecting the images to a process of radical conceptualization in order to eliminate the possibility of aesthetic consumption. On the other hand, it does not use any of the usual Pop techniques of image reproduction or collage, sticking instead to the traditional techniques of oil painting. He thus creates a certain tension between the mechanically reproduced image and the traditional "privileging of technique" (Walter Benjamin). Last-

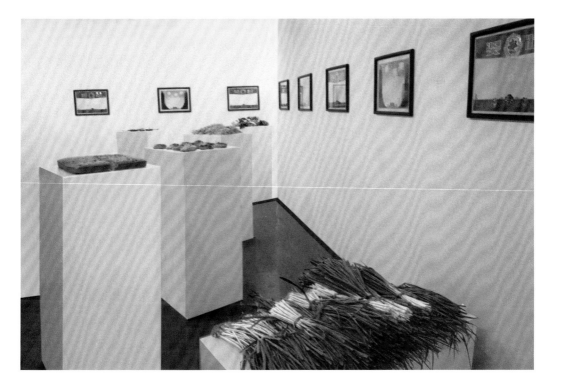

pp. 158–59
Wang Guangyi,
Basic Education, 2001
Official Chinese anti-
war propaganda from
the 1960s, construction
scaffolding and military
shovels, variable
dimensions
Partial view of the
exhibition *Thing-In-Itself:*
Utopia, Pop and
Personal Theology,
Today Art Museum,
Beijing, China, 2012
Courtesy Today Art
Museum, Beijing
Photo Wang Junyi

ly, and perhaps most importantly, unlike Pop, the subjective experience that is condensed within *Great Criticism* is not the current consumerist culture but historic materialism (that the artist would later call "the socialist visual experience"). Like the fetishist culture of consumerism, this historical period is profoundly marked by transcendental and theological qualities – its theology consists of leaders and people. In *The Open Society and Its Enemies* Popper appreciates the "interesting analogy" of Arnold Toynbee: "Marx has taken the Goddess 'Historical Necessity' in place of Yahweh for his omnipotent deity, and the internal proletariat of the modern Western World in place of Jewry; and his Messianic Kingdom is conceived as a Dictatorship of the Proletariat".[64] Louis Althusser observes this alienating aspect of history from an opposing standpoint: in Christianity, God is the subject par excellence ("I am that I am"), and calling individuals (believers) subjects of the Subject establishes a relationship of mutual recognition between them in order to complete the domination of the sacred over the earthly world. A mirrored version of this ideological structure exists within every ideology, so that the leader and the people are also in this subject-subject relationship.[65] The Chinese Cultural Revolution is both a typical and extreme historical case in this regard. As for *Great Criticism*, its intention is not to provide a moral explanation, but instead to position the meta-narrative symbol represented here by the people in non-linear contradiction to the material symbol that is the product, so that interpretations of the work remain more open:

> The significance of the Cultural Revolution, for me, does not coincide with most people's viewpoints (their political and economic readings of it). ... That is because the viewpoint of most people might be more focused on the real results

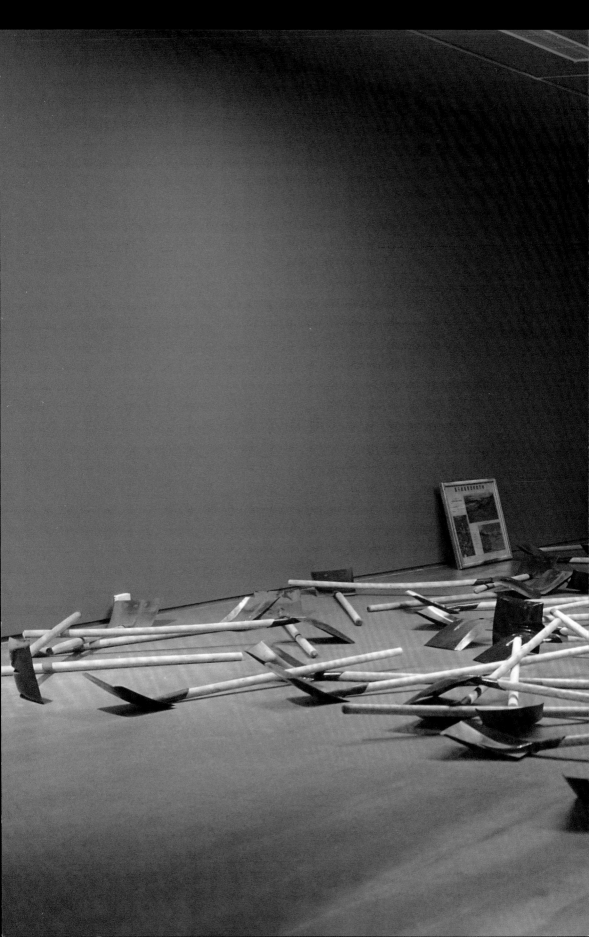

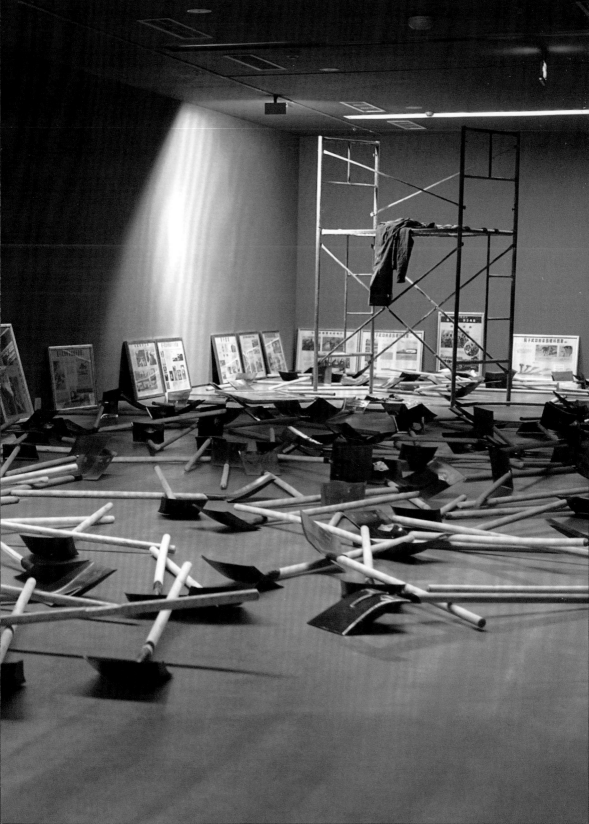

that might be brought about by an historical incident. As for the artist's view, he tends to be more concerned with the complexity of the visual forms that are derived from the historical incident. As the artist reveals this visual complexity, he is also able to modify two different perspectives.[66]

When I positioned propaganda posters next to Coca-Cola, the spiritual goal was to create a connection between utopia and fetishism. I think that people should approach my provocations seriously, with the sense of the sacred.[67]

Gian Lorenzo Bernini, *Ecstasy of St. Theresa*, 1647–52, detail Marble, h 350 cm (137 3/4 in.) Church of Santa Maria della Vittoria, Rome

In the past, Wang Guangyi has searched for a dramatic analogy between the standardized theatrical performances of the Cultural Revolution (as in *Great Criticism: Red Women's Army*), Chardin's peasants, Bernini's *Ecstasy of St. Theresa* and Van Gogh's *Potato Eaters*, to affirm the theological values of the people – in the historic sense:

> People have a kind of primitive imagination and creativity. ... When someone creates something, and it is universally accepted and disseminated, it becomes a very important part of spiritual life or even everyday life. ... I think that my artworks embody this referential value; the images I use come from *the people*, and I think that *the people* can objectively read my works. My works indeed have certain mystical aspects that perhaps are not immediately attainable, but the basic meaning is clear and graspable. I did focus my efforts for a long time on removing ideas and perceptions that were strictly personal, in an effort to express shared concepts that belonged to the idea of collectivity. In reality, I can't truly know what the people are thinking, but ever since *Great Criticism*, I have worked from this assumption. It is just a supposition, but without suppositions, the artist loses all reasons for being. We are not scientists, nor are we thinkers or philoso-

phers. We have no duty or need to disseminate objective knowledge to the public. What the artist should do is strive to imagine a world, and to imagine the meaning and relationship his works have with the public. The question of how things are in reality is really not my concern.[68]

It may seem strange that this is the psychological disposition of a Pop artist, but indeed it is so. In terms of stylistics, *Great Criticism* is a kind of half-way Pop, a variant Pop, one that seeks an alternative history beyond the one decided on by Pop; a history that produces meaning through the encounter of two specific ideological experiences: that of the global consumer culture and that of the specific historical period. Behind that seemingly radical strategy of representation, the artist is still concerned with the classical question: how art, in different cultures, can still maintain its divine essence. He directly describes the difference between his historicist Pop and the Pop of Andy Warhol:

I'm actually quite jealous of Warhol's purity and spontaneity, but there's something in my personality that always pulls me towards the unknown and the uncertain. This is a very painful experience, one that I must endure alone. The absence of meaning disseminated by Warhol can be connected to his choice of images. His images are not very meaningful, or perhaps they are meaningless. Though the forms are clear and the schema simple, they are not the result of a process of the professionalization of art. Deep down, they are the products of the universal decline in spirituality.[69]

Great Criticism brought the artist great success, but oddly, just as soon as it became revered by the market, politics and the international press, its theological import disappeared, and it came to be seen largely as a fashionable diversion or sales strategy. In 2000, this led the artist to give up portraying the dual-images found in *Great Criticism* and move on to create a series of what I will call "materialist theological" off-canvas pieces, such as *Age of Materialism*, *Fundamental Education*, *Materialist* and *East Wind – Golden Dragon*. In *Visual Politics: Another Side of Wang Guangyi*, I analysed these artworks from another perspective.[70]

The Thing-in-Itself

Augustine believed that God was all-knowing, all-powerful and totally free. He created the material world completely from nothing, with no need for pre-existing materials. On this point, I borrowed some of his reflections, and in a certain sense, I replaced God with the artist. This is connected to the creation of my latest work, the ready-made *Inflammable and Explosive*. I believed that the artist should use his own intuition to create and should create out of nothing, to undergo his own process of discovery within the confines of nature. This new method was completely different from that of *Great Criticism*; it was dark leaning, an absolute mystery.[71]

The above was Wang Guangyi explaining his first ready-made piece *Inflammable and Explosive* in a recent interview. This work, which was actually made at the same time as *Great Criticism*, was like a different key within the same song, whose overtones can only be heard when the two are in harmony. If *Great Criticism* was a response to the materialist philosophy of Andy Warhol, then *Inflam-*

161

Artist retired to his
chess board: Marcel
Duchamp playing by
the hour at a table with
a clock that keeps
track of the time
between moves, 1952

Wang Guangyi,
Freedom of Choice,
1994
Artificial fur, projector
Performance at the Art
Museum of Capital
Normal University,
Beijing, China, 1994

left
Joseph Beuys at
the conference where
the German Green
Party was founded,
12 January 1980

pp. 166–67
Wang Guangyi,
Sacred Object, 2012
Oilcloth,
120 x 80 x 1000 cm
(47¼ x 31½ x 393¾ in.)
Exhibited at *Thing-In-Itself: Utopia, Pop and Personal Theology*,
Today Art Museum,
Beijing, China, 2012

left
Wang Guangyi,
detail of *Sacred Object*,
2012

mable and Explosive was a response to the spiritual theology of Marcel Duchamp and Joseph Beuys, a response that is connected to the "material spirit" that the artist has always emphasized. Form and matter are core concepts in Aristotle's metaphysics (or theology). Bertrand Russell said that "the Orphic elements in Plato are watered down in Aristotle and mixed with a strong dose of common sense".[72] In Aristotle, Plato's vague, illusory ideas become forms, the only substance of things as things, while matter is that which allows for the making of this substance. Their relationship is as sculpture to stone; without a realized form, it is only a possibility. Another metaphor in Aristotelian metaphysics has to do with the body and soul. The soul is the body's final cause: "The soul must be a substance in the form of a natural body having life potentially within it. But substance is actuality, and thus soul is the actuality of a body as above characterized".[73] But these two metaphors both conceal a basic contradiction: form, or perhaps the spirit or the soul as a pure form, is eternal and unchanging, the unmoved mover, the final cause of all activity, while matter or the body is eternally incomplete, able only to pursue or approach form or spirit. And thus Russell says, "But when potentiality is used as a fundamental and irreducible concept, it always conceals confusion of thought. Aristotle's use of it is one of the bad points in his system".[74] Aristotle explained this contradiction by separating the soul into rational and irrational components. Only the rational soul, or the mind that did not have such a close connection to the body, could allow for an approach towards the eternal. "He believed only that, in so far as men are rational, they partake of the divine, which is immortal. It is open to man to increase the element of the divine in his nature, and to do so is the highest virtue. But if he succeeded completely, he would have ceased to exist as a separate person".[75]

We may not fully understand whether or not Wang Guangyi's material spirit is connected to Aristotle's contradiction; neither can we determine if it is a reasonable concept. But from the artist's description, the material spirit is at least connected to the sacredness in art that he has always been concerned with, as well as to that hyper-philosophized nihilist attitude that characterizes contemporary art. In fact, the material spirit is precisely what he speaks of when describing the differences between himself and Beuys:

The concepts in Beuys's works were perhaps too invasive. The material aspects of his works were second to the intellectual component. As a result, most of his artworks could not be preserved – just think of his performance pieces and site-specific installations. The majority of his works could not be documented; on the contrary, I have taken a relatively classical attitude, in that I place importance on the material aspect of artworks, its *material spirit*, and by this I mean that the spirit is presented through a certain material element. This concept may be connected to the materialist education we received as children. I believe that there must be a tangible material in order to undertake the spiritual mission, or alternatively, that the spirit or soul can only find expression through a certain physical carrier. That's my view on the power to grasp and give a concrete form to the spiritual dimension. As a result, I don't do performance art, and I don't like concepts involving participation and interaction. I think all of that is too short-lived, too impermanent. All of my works have … substantial material carriers, and this implies that all of my souls have a sanctuary. I must think about my art and face it in this way to keep my conscience clear. … Art is destined for only a minority of people. I must be clear on that point. I think that Beuys's excessive expansion of art onto all objects and all behaviours is quite suspect.[76]

A propaganda poster
from the 1960s for
harvesting wheat

Wang Guangyi,
studies for *Things-In-
Themselves*, 2011
Felt-tip pen and
watercolour on paper,
42 x 29.5 cm
(16¹/₂ x 11⁵/₈ in.) each
Collection of the artist,
Beijing, China

Though he has always taken Duchamp's revelatory concept that thought is art seriously, and though he was quite jealous of Beuys's natural oracular air, Wang Guangyi also carefully looked after what he saw as the artist's professional role; which for him meant creating objects and making use of divine inspiration which was integral to this act of creation. As he saw it, neither an excessively technical behaviour (creating beauty) nor an excessively philosophical one (creating concepts) could assure art's genesis in terms of divine creation.

In *The Origin of the Work of Art*, Heidegger uses philosophical and theological methods to discuss how objects can first become works of art, and then become "art", by which he meant an alluded to or disclosed unconcealed truth, manifested as a whole world that cannot be revealed: a "thing-in-itself". According to Heidegger, the artist's process of transforming matter into form required both pre-existing faith as well as intuitive experience; it was still a historical process of participation.[77] All this happens to coincide with the psychological disposition at the core of *Inflammable and Explosive*. This ready-made was created during a moment of historic change generated by an important political event. This historic/political condition placed the artist before an extreme tension between two opposing feelings: fearing for his life, and keeping the faith. His was not a difficult provocative exercise like Duchamp's urinal, but the kind of psychological reaction that comes from a submission to history. The crude packaging materials and the indecipherable symbols in plain sight recreate this emotional state and make it the object of an ambiguous and uncertain condition. The series of widely sourced ready-mades that followed showed the desire to obtain and combine elements from historical experience, from faith, and from sensory perception. The various materials used in these works, such as clay and thermometers in *China Thermometer* and *Comparison between Chinese and American Temperature* (1990), the vegetables in *Quarantine – All Food is Potentially Poisonous* (1996), the millet in *Materialist* (2001), the shovels and scaffolds in *Basic Education* (2001) and oilcloth in the recent *Sacred Object* (2012), hailing from specific historical and psychological conditions, have a completely different symbolic function than his canvas paintings. The difference between the two can be likened to the difference between *acheiropoieta* (icons made without hands) and the sacred icons in Christianity. If we can read works like *Great Criticism* by relying on common art history knowledge, then the ready-made works require a more elaborate sense of history and mental resilience, which, according to Wang Guangyi, has to do with historicism and mysticism. He once warned a Western reader:

> The meaning and spirit of Beuys's hare fur cannot be understood by someone with no involvement in European culture, and would even be quite confusing, as hare fur is nothing more than hare fur. On the other hand, if you have no knowledge of Chinese culture, then millet is nothing more than millet.[78]

The "thing-in-itself" is both a central concept in Wang Guangyi's artistic philosophy and the name of the title work in his 2012 retrospective exhibition. In his eyes, "things-in-themselves" and daily sacred objects are connected:

> As I see it, Kant's thing-in-itself is a concept that is at once extremely ordinary and extremely sacred. He established the thing-in-itself as something that our rational minds can never recognize but which also constantly stimulates our perceptions;

pp. 172–73
The installation of *Things-In-Themselves*, 2012 at the exhibition *Thing-In-Itself: Utopia, Pop and Personal Theology*, Today Art Museum, Beijing, China, 2012

pp. 174–75
Wang Guangyi, *Things-In-Themselves*, 2012
Jute sacks, rice and rice bran,
300 x 110 x 1200 cm
(118^1/$_8$ x 43^1/$_4$ x 472^1/$_2$ in.)
Exhibited at *Thing-In-Itself: Utopia, Pop and Personal Theology*, Today Art Museum, Beijing, China, 2012

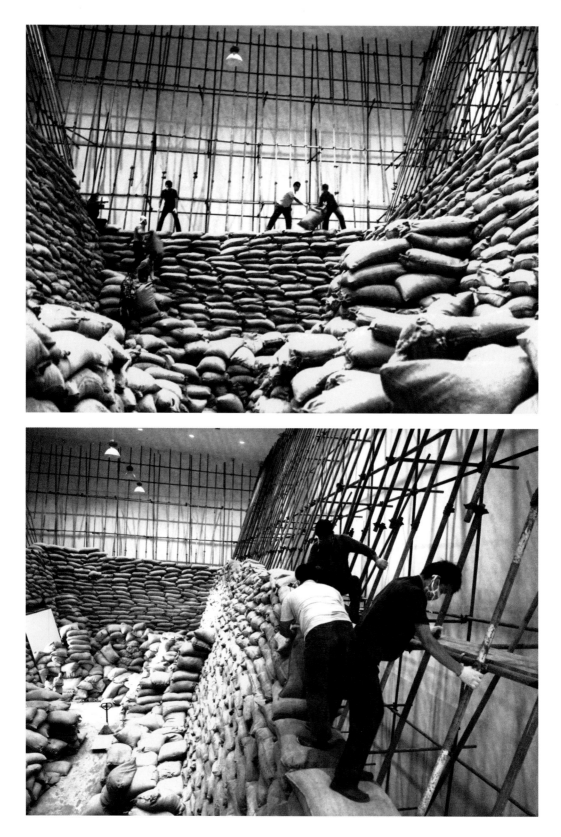

we perceive its existence, without knowing its origin. Beyond it, however, there is certainly a revealer that sustains it. ... The information I draw from the Kantian notion of the "thing-in-itself" is this: behind the object we see there exists an unknown force, which induces it to appear before us in a specific way, and this force is not something that we can understand through knowledge. At the time, I saw such a force in Chardin's still lifes. I can't say more than that; I am incapable of using the language of common knowledge to describe this process in detail.[79]

For Kant, the thing-in-itself is the cause and boundary of knowledge, our form of *Anschauung*: time and space can only partially experience it and can never fully verify it. This epistemology is part of a philosophical system with a metaphysical element which Russell calls the "awkward element in Kant's philosophy".[80] Nietzsche, on the other hand, takes this to the extreme and calls it a "useless theory" and a "contradictory concept": the "thing-in-itself" cannot be known, and once it is known, it is no longer a "thing-in-itself". Nietzsche did not, however, entirely reject the "thing-in-itself"; instead he replaced it with the real world: another contradictory world that is behind our apparent world, it fabricates for us, but we cannot know or grasp it.[81]

Perhaps, for Wang Guangyi, proving the theory of the thing-in-itself is not so important. The inspiration he derives from it far surpasses its scientific meaning. Its unknowable traits are perfectly in line with the spiritual conflict between the transcendental and empirical worlds, and between the classical and contemporary worlds.

The large installation *Things-in-Themselves*, which the artist created in 2012 for his Beijing retrospective exhibition, is essentially a visual translation of these reflections. This artwork occupies the entire 900 square metres of the Today Art Museum's main exhibition hall. The four walls are stacked with countless layers of rice-filled burlap sacks, which give the space a dual nature: it could be a grain storehouse or it could be a church. The seven bright and evocative lights on the ceiling and the powerful aroma of rice in the room inebriate the senses. Twenty years ago, Wang Guangyi compared artists to people stuffing rice into burlap sacks: "The artist is like he who knowingly stuffs sacks; if the sack has spirituality, the artist obtained it by chance, but if a painting has spirituality, the artist obtained it by necessity. Stuffing is creation".[82] Twenty years later, he has turned this metaphor into a visual reality; I do not know whether this metaphor has been expanded or contracted. Gombrich once joked about the well-meaning museum guide who discovered a mysterious, infinite world behind a pile of clay. He warns us that the over-interpretation typical of contemporary art not only hinders the discovery of real artistic questions, it dulls our ability to appreciate art.[83] To avoid the same fate, I will stop interpreting in hopes that within these pages the reader may find the relationship between the concepts on which Wang Guangyi's work relies, and the theoretical questions the artist has confronted.

The Artist's "Sacred Books"

It is absurd to simply equate the artist's knowledge gained through reading to his artistic experience, yet to completely overlook the books he has read or the impact of them on his character and artistic achievements would be dangerous.

Wang Guangyi has mentioned several times that reading offers him more than knowledge; it provides channels of inspiration. This understanding is extremely beneficial for our interpretation of his art. I have chosen three books that he read at different turning points in his life and artistic career to demonstrate that reading has either impacted his attitude towards the world, or has had a direct influence on his choice of art-making.

Reading is an encounter, as impermanent as fate: there is not one book that will lead us down the right path in life. However, sometimes, a book can change our attitude and quality of life. For Wang Guangyi, it was Jack London's *Martin Eden*. Wang Guangyi read this uncelebrated American novel in the mid-1970s during a period of hardship in his life when he was sent to the countryside and served as a railway worker after failing his university entrance exam; these events provide the psychological context for his encounter with this novel. Later he recounted, "What saved me was my mother's spirit and Jack London's portrayal of Martin Eden". If his mother's forbearing and kind nature saved him from losing trust in others even under dangerous situations and dire circumstances, then Martin Eden's theatrical life experiences of having lived through impoverishment to wealth and nobility to self-destruction became a textbook that he digested and contemplated thereafter. Guangyi has said, "I have never read any book with this level of fascination, tucking it in my jacket, leaving it under my pillow; I read it over and over again. It was the basis for my later knowledge of Van Gogh, Nietzsche, Christianity, Zhuangzi and even Machiavelli. Its impact on me thereafter was tremendous". His unique understanding of the cruelty of society, his realization of the impermanence of the human condition and his audacious character in his artistic practice are all deeply imbedded in every detail and scenario of this book.

In 1980, Wang Guangyi was finally enrolled at the Zhejiang Academy of Fine Arts, an institution he had dreamt of attending. But very soon, he became annoyed with the academic realism, even the various genres of modernism weren't exciting to him. Instead, he was fascinated with the ruins of the enigmatic ancient Roman art and its solemn yet simple forms. During this year, like many young intellectuals studying art at the time, Wang Guangyi began to read philosophy. He was not interested in the modernist philosophy that was fashionable at the time, but in the mythological theories of the Middle Ages, and the sacred philosophy of ancient Greece and Rome. Bertrand Russell's lightly toned *History of Western Philosophy* provided him with a map of Western thought: "There are four figures I have read over and over again in Russell's book – they were Augustine, Aquinas, Kant and Machiavelli". Within this map, he first discovered Kant's "thing-in-itself", a semi-mythological, semi-philosophical spiritual castle. This concept originates from *The Critique of Pure Reason*. Wang Guangyi, however, was not interested in the complex logical analysis relevant to the idea, but in the unknown locked behind the concept. This enigma guided him in discovering the logic of the nihilistic creation of the world in Augustine's theory of Genesis, the hypothesis that the true world was hidden behind this world, and the search for similarities between the artist and God. Then, he told me, "Kant impacted me because of his use of two terms: antinomy and thing-in-itself. I have often used these words in my writings". Without such a literary background, it would be difficult to grasp his corresponding artworks such as *Frozen North Pole*, *Post-Classical* and the *Rationality* series, or even to make a valid historical judgement of his life-long art practices. "Thing-in-itself" – a concept that has been adopted over

and over again in Wang Guangyi's own logic – has become a key for us to enter his artistic world.

1987 was a turning point for Wang Guangyi's art. He left the heart of the artistic movement for the remote city of Zhuhai. Two years within the New Wave movement had solidified his position in the art world, but Guangyi's self-spirited approach and definitive tendencies were gradually becoming out of place. Then, a revelatory book on art theory entered his horizon: *Art and Illusion*, a famous volume by the British art historian Ernst Gombrich. Gombrich has adopted Karl Popper's concepts of "conjectures and refutations" to study the "known and seen" of ancient Western art, and how it has affected the production of images through its representations of the world. The work treats Western art as a long process of "image revision"; what affected this process besides the production of iconography and its relevant logic within art is determined by the complex situational logic of various competitions within art (or the "logic of vanity fair"). If the Kantian "thing-in-itself" and "antinomy" shaped Wang Guangyi's logic and modes of thinking in his artistic spirit, then, "image revision" and "situational logic" are the two concepts that grounded his intelligence, knowledge and psychology as he developed into an open-minded contemporary artist. The misreading of this culturally dense art history theory was what led Wang Guangyi down his artistic path. Yan Shanchun described the critical effect of this volume in a biography on Wang Guangyi in the first person:

> In 1987, I began to slowly deviate off-centre from this movement, and was breaking away from the confining provincial thinking. I redirected my vision from the metaphysical philosophy to the history of art, and the various legends found there. Gombrich's image theory provided me with some revelations. The images not only help us to observe and express the world, but also to revise it; to simplify it by cutting out the superfluous, and to unveil the truth by removing the disorder. Through revisions of famous historical works, I have created a series of post-classical artworks through which I have established my own artistic trope. The composition of my images is calm and solemn, grounded colour tones and structural symmetry demonstrate an aura of dignity and the sublime. I have reinvented Gombrich's image revision and turned it into cultural revision, transforming his visual theory into spiritual theory. I have found the ever-present spirituality that already existed in the history of art. I learned how to appropriate through others and through history. My vision is not comparable to the change of figures in *Luncheon on the Grass* by Edouard Manet. For him, the historical tradition was only a form. For me, I am assigning a new spirit to a classic. Artistically speaking, I am not a determinist of history, as it is not definite. There is continuity in human knowledge, but it is illogical because humanity has never marched forward in unison towards one goal. I appreciate the theory of the veil of ignorance in economics.

Borges said, "Any book is a sacred object"; of course by "any book" he was referring to the sacred books and all books that deciphered the holy during spiritual times. If this phrase was used on an artist, it would be, "Any book that has inspired the artist is a sacred object", for they become the reference for and evidence of the sacredness of artistic creativity. For Wang Guangyi, Jack London's *Martin Eden*, Kant's *Critique of Pure Reason* and Gombrich's *Art and Illusion* are "sacred books".

Conclusion

The collapse of faith is one of the historical events at the foundations of modernism. In God's absence, the world suddenly falls into a "fearsome ambiguity".[84] But paradoxically, this has not eliminated the need for faith. To the contrary, it has become a universal individual choice among intellectuals who understand it as more rational than intuitive. For Kierkegaard, this choice manifests itself as individual salvation in the logical distinction between hopelessness and faith; for Benjamin, this choice results in the reestablishment of the broken link between the solitary individual and the transcendental home, an allegorical self-redemption that has nothing to do with the age of epics; for Heidegger this choice reveals an attraction for and approach towards the age of the divine after falling into the abyss of the age of technology. Within Christianity, efforts towards restoring faith become increasingly individualized. Contemporary theologian Ernst Troeltsch decidedly confirmed the reasonableness of the shift from collective faith to individual awareness, considering the absoluteness of the religion professed by individuals to be equal to that professed by religious doctrine in terms of their redemptive ends.[85] According to Kierkegaard, Christianity is not interested in the historical actions of the Roman conquerors, but in what a few fishermen gave the world.[86]

Wang Guangyi does not adhere to a specific faith, though his art is full of allusions to and reflections on the transcendental world; nor is he an atheist in the true sense, though his view of history is clearly marked by determinism. His artistic vision is complex and cogent, it contains the allegories of oracular philosophy and the reflections of rationalism, but as an artist, his questions and projects are clear and logical. He hopes that within the cracks that separate two clashing worlds and eras there is a place for his art which he treats as the carrier of his individual theology:

> I view art as a product of faith. … I think that the presence of something mysterious is necessary for art. When art loses its sense of mystery, it becomes a mere craft, and this is why I have always been a defender of traditional artistic values.[87]

In this sense:

> He is his own prophet and redeemer.

Wang Guangyi and Huang Zhuan, Beijing, 2005
Photo Wang Junyi

Acknowledgements

Between the late 1970s and the early 1980s, young artists from all over the world drew from the rich artistic traditions of Old World Europe and from the European experiences that had developed after the second half of the nineteenth century; thus they gave life to extraordinary avant-garde art. The 1980s obviously did not just look to Europe for inspiration. In so-called postmodern art we find echoes of Action Painting, Pop and Minimalism. Edward Hopper's Realism and de Kooning's brushstrokes began to converse and cohabitate within one singular painting, providing proof that the formalist juxtapositions theorized by Clement Greenberg had been surpassed. This idea that *everything mixes and lives together* was and continues to be an expression of the desire for globalization that lived and continues to live in the West.

I am Chinese, and my artistic vision bears the weight of the history of the Chinese people. It could not be otherwise. I realize that there have been many misconceptions about Chinese art. These misconceptions are born from the fact that Chinese art has been read using Western parameters. We certainly have much to learn from the West, just as the West has much to learn from the East. If we do not start by presuming that exchanges of information are necessary, China will never fully understand Western art, and the West will never fully understand Chinese art. Wang Guangyi's work, for the historic importance it has assumed and continues to assume, offers a precious opportunity for approaching the complexity of our contemporary culture.

In China, in the second half of the 1970s, when the Cultural Revolution had just ended, a modernist artistic movement was being born, though the rest of the world remained unaware. This movement, guided by Renaissance and Enlightenment ideals, had a profound impact on China, and it subtly shifted the coordinates of the art world – though these changes are only becoming evident now, more than three decades later.

Wang Guangyi is a protagonist of this movement. In 1984, when he joined other artists from Northern China to give life to the first Chinese art group (the Northern Art Group), he was only 27 years old – the same as Nietzsche was when he wrote *The Birth of Tragedy*, donning the Dionysian mask as he declared war on God; the same age as Beuys when he studied at the Düsseldorf Academy of Fine Arts under the guidance of Ewald Mataré, and, having discovered Rudolf Steiner's Anthroposophy, decided to change the art world. At 27 Wang Guangyi also wanted to change the art world, and to do so he believed that it was necessary to position the "frigid zone civilization" against the increasingly weak and noxious contemporary civilization.

Later artistic experiences proved that these utopian ideals were precisely what insured the global perspective of his art. He drew from a multitude of delicate and complex resources, from mediaeval theological iconography to contemporary political themes, from the humanist ideas of the Renaissance to low-brow Pop culture, making each one merge into his various artistic methodologies and projects. His work has mapped global movements from the Cold War to the age of globalization, and he has registered contemporary Chinese art's re-

action to these drastic global changes exactly in the way a written text would. His particular case shows that it does not matter how broad geographical and cultural differences are: the works of a great Chinese artist can be completely understood and absorbed by the Western spectator. It is this certainty that prompts my interest in the Western reader's response to this work.

This version of this book is the result of an encounter with Demetrio Paparoni, whom I met through Wang Guangyi, and with whom I have become great friends. His profound knowledge of Wang Guangyi's work and his sincere enthusiasm have allowed us to share many perspectives on contemporary Chinese art. His essay on Wang Guangyi that was published in the exhibition catalogue for the show *Thing-In-Itself: Utopia, Pop and Personal Theology*, which I curated at the Today Art Museum of Beijing in September 2012, is an in-depth analysis of the theological aspects of Wang Guangyi's work. I consider our friendship the result of the desire for a strong interaction between two academic traditions.

I must give particular thanks to Jeff Crosby who first translated these texts into English, and to Elio Cappuccio and Julia Heim for their support in insuring the relevance and strength of the philosophical themes discussed here. Their professionalism has guaranteed the success of this inter-linguistic exchange. Additional thanks go to Wang Junyi, who has provided continued and generous support throughout my research on Wang Guangyi, including this publication.

I would also like to extend my sincere appreciation to Marko Daniel of the Tate Modern: not only has he studied my research topic in depth, but has carried out serious and open discussions with me on the subject. He is one of the few museum curators and scholars who, with genuinely sympathetic attitude, have been able to make rational observations on contemporary Chinese art. He has provided valuable comments on this subject matter from a Western scholar's perspective.

Wang Guangyi in his
studio, 2009
Photo Wang Junyi

Notes

[1] Howard Felperin, *Beyond Deconstruction: The Uses and Abuses of Literary Theory* (Oxford: Oxford University Press, 1985), 119.

[2] Friedrich Nietzsche, *The Will to Power* (New York: Random House, 1967), 429.

[3] *Lixiang yu Caozuo: Zhongguo Guangzhou – Shoujie Jiushi Niandai Yishu Shuangnianzhan Youhua Bufen* [Ideals and Operation: China Guangzhou – First '90s Art Biennial, Oil Painting Segment] (Sichuan: Sichuan Fine Arts Publishing House, October 1992), 104.

[4] Li Xianting, "'Hou 89' Yishu zhong de Wuliaogan he Jiegou Yishi – 'Wanshi Xieshi Zhuyi' yu 'Zhengzhi Bopu' Chaoliu Xi" [Feelings of Boredom and a Deconstructive Mentality in 'After '89' Art: Analysing the Trends of 'Cynical Realism' and 'Political Pop'], in *Piping de Shidai: 20 Shiji mo Zhongguo Meishu Piping Wencui* [A Time of Criticism: A Collection of Chinese Art Criticism from the Late Twentieth Century], Vol. 1 (Guangzhou: Guangzhou Fine Arts Publishing House, 2003), 386.

[5] Duan Lian, *Shiji mo de Yishu Fansi* [Rethinking Turn of the Century Art] (Shanghai: Shanghai Art and Literature Publishing House, 1998), 142.

[6] Ibid., 12.

[7] Huang Zhuan, "Wei Guangqing: yi zhong Lishi hua de Bopu Zhuyi" [Wei Guangqing: An Historicized Form of Pop], in *Zuo Tu You Shi* [Interplay of Images and History] (Guangdong: Lingnan Fine Arts Publishing House, 2007), 1.

[8] Lü Peng, "Tuxiang Xiuzheng yu Wenhua Piping" [Image Alteration and Cultural Criticism], in *Dangdai Yishu Chaoliu zhong de Wang Guangyi* [Wang Guangyi within the Trends of Contemporary Art] (Sichuan: Sichuan Fine Arts Publishing House, 1992), 36.

[9] Wang Guangyi, "Qingli Renwen Reqing" [Clearing Out of Humanist Passions], in *Jiangsu Huakan* [Jiangsu Pictorial] 10 (1990).

[10] Wang Guangyi and Wu Shanzhuan, "Guanyi Yixie Wangshi de Fangtan" [A Discussion about Some Things from the Past], in *Asia Art Archive* (unpublished).

[11] Zhao Tingyang, *Lun Keneng Shenghuo* [Discussing the Life Possible] (Beijing: China People's University Publishing House, 2004), 7; *Meiyou Shijie guan de Shijie* [A World without a World View] (Shanghai: China People's University Publishing House, 2003), 3.

[12] Yan Shandui, "Dangdai Yishu Chaoliu zhong de Wang Guangyi" [Wang Guangyi within the Trends of Contemporary Art], in *Wang Guangyi within the Trends of Contemporary Art* (Sichuan: Sichuan Fine Arts Publishing House, 1992), 20.

[13] Lü Peng, "Image Alteration and Cultural Criticism", 42.

[14] Yan Shandui, "Wang Guangyi within the Trends of Contemporary Art", 21.

[15] Lü Peng, "Image Alteration and Cultural Criticism", 40.

[16] Wang Guangyi, "Wo Jinqi de Guongzuo Qingkuang" [My Recent Work Situation], in *Gallery* 4 (1994).

[17] Ibid.

[18] *Shoujie Dangdai Yishu Xueshu Yaoqing Zhan* [Catalogue for the First Contemporary Art Academic Invitational Exhibition] (Guangdong: Lingnan Fine Arts Publishing House, 1996), 122.

[19] Dani Cavallaro, *Critical and Cultural Theory* (New Brunswick, NJ: The Athlone Press, 2007), 84.

[20] "Guanyu Shehui Zhuyi Shijue Jingyan" [About the Socialist Visual Experience], interview of Wang Guangyi by Charles Merewether, in *Wang Guangyi*, HanART Gallery, 2002.

[21] "Chongxin Jiedu: Zhongguo Shiyan Yishu Shi Nian" [Reinterpreting: Ten Years of Chinese Experimental Art], in *Beijing Youth Daily*, 28 November 2002.

[22] *Bei Yizhi de Xianchang: Di Si Jie Shanzhen Dangdai Diaosu Yishu Zhan* [Transplanted Scenes: Fourth Shenzhen Contemporary Sculpture Art Exhibition], catalogue, 119.

[23] Wang Guangyi, *Huangquan Zuihou de Zanli* [The Last Gesture to Imperial Power] (unpublished).

[24] Excerpted from "Wang Guangyi: Faxian 'Leng Zhan' zhi Mei" [Wang Guangyi: Discovering the Beauty of the "Cold War"], in *Guangzhou Daily*, 29 December 2002.

[25] Ibid.

[26] Erwin Panofsky, "Idea, a Concept in Art Theory", translated by Gao Shiming, in *Meishu Shi yu Guannian Shi* [Art History and Conceptual History Vol. II], edited by Fan Jingzhong and Cao Yiqiang (Nanjing: Nanjing Normal University Press, 2010).

[27] Friedrich Nietzsche, *The Will to Power*, 419 n. 794.

[28] "Us – the Participants of the '85 Art Movement", in *Zhongguo Meishu Bao* [Fine Arts in China] v. 36 (1986).

[29] Wang Guangyi, "Women Zhege Shidai Xuyao Shenmeyang de Huihua" [What Kind of Painting this Era of Ours Needs], in *Jiangsu Huakan* [Jiangsu Pictorial] v. 4 (1986), 33.

[30] Yan Shanchun, "Dangdai Yishu Chaoliu Zhong de Wang Guangyi" [Wang Guangyi within the Trends of Contemporary Art], in *Wang Guangyi within the Trends of Contemporary Art* (Sichuan: Sichuan Fine Arts Publishing House, 1992), 3.

[31] Johan Huizinga, *The Waning of the Middle Ages* (New York: Dover Publications, 2013), 187.

[32] Ibid., 183.

³³ Paul Cézanne, *Letters*, edited by John Rewald: letter to Bernard, 15 April 1904 (London: Bruno Cassirer, 1941), 234.

³⁴ Ernst H. Gombrich, "The Heritage of Apelles", in *Yishu yu Renwen Kexue – Gongbulixi Wenxuan* [Art and the Humanities – Selected Writings of E. H. Gombrich], edited by Fan Jingzhong (Zhejiang: Zhejiang Photography Press, 1989), 211.

³⁵ Friedrich Nietzsche, *The Will to Power*, 419 n. 796.

³⁶ "Xinchao Meishujia (Er) Wang Guangyi" [New Wave Artist (II): Wang Guangyi], in *Zhongguo Meishu Bao* [Fine Arts in China] v. 39 (1987).

³⁷ Ernst H. Gombrich, *Art and Illusion* (London: Phaidon Press, 1960), 88.

³⁸ Ibid., 99.

³⁹ Ernst H. Gombrich, "Art and Illusion: A Study in the Psychology of Pictorial Representation", translated by Lin Xi, Li Benzheng and Fan Jingzhong, in *Xiandai Meixue Wenxuan: Lun Yishu Zaixian* [Selected Writings on Modern Aesthetics: On Artistic Representation], Meishu Yicong [Fine Arts Translation Series] (Zhejiang: Zhejiang Photography Press, 1987), 2–6.

⁴⁰ Hong Zaixin, "Pipan de Tushi yu Tushi de Pipan" [Critical Schema and Schema Criticism], in *Wang Guangyi within the Trends of Contemporary Art*, 65.

⁴¹ Yan Shanchun in *Wang Guangyi within the Trends of Contemporary Art*, 14.

⁴² Yan Shanchun, "Wang Guangyi He Wo Tan Shenhua yu Youxi" [Wang Guangyi Talks with Me about Myths and Games], in *Wang Guangyi within the Trends of Contemporary Art*, 75.

⁴³ Ibid., 74.

⁴⁴ Ibid., 75.

⁴⁵ Yan Shanchun, *Wang Guangyi Fangtan Lu* [Wang Guangyi Interview], Beijing, Hangzhou and Shenzhen, 2011 (unpublished).

⁴⁶ Ernst H. Gombrich, *Gombrich on the Renaissance: Symbolic Images* (London: Phaidon Press, 1985), 13.

⁴⁷ Ibid.

⁴⁸ Yan Shanchun, *Wang Guangyi Talks*, 75.

⁴⁹ Hu Lizhan, *Wang Guangyi Rushi Shuo* [Wang Guangyi Says], in *Gallery Magazine* v. 19 (1989), 19.

⁵⁰ Wang Guangyi, "Duihua: Guanyu Ren de Xiaoshi he Yishu Chuangzao de Er Wo Fenli" [Discussion: On the Disappearance of Man and the Separation of Two Selves in Artistic Creation], in *Yishu Guangjiao* [Wide Angle on Art] v. 4 (1989), 51.

⁵¹ Ibid.

⁵² Lü Peng, *Wang Guangyi's Art History* (Hunan: Hunan Fine Art Publishing House, 2008).

⁵³ Wang Guangyi, "Guanyi Qingli Renwen Reqing" [On the Clearing Out of Humanist Passions], in *Jiangsu Huakan* [Jiangsu Pictorial] v. 10 (1990), 17–18.

⁵⁴ Ernst H. Gombrich, "Aims and Limits of Iconology", in Id., *Symbolic Images* (London: Phaidon Press, 1972), 1–25.

⁵⁵ Wu Hung, "Face of Authority: Tiananmen and Mao's Tiananmen Portrait", in *State Legacy: Research in the Visualization of Political History* (Manchester: Righton Press, 2009), 442–77.

⁵⁶ Lü Peng, "Tushi Xiuzheng yu Wenhua Pipan" [Schema Correction and Cultural Criticism], in *Wang Guangyi within the Trends of Contemporary Art*, 36.

⁵⁷ Ernst H. Gombrich, "Aims and Limits of Iconology".

⁵⁸ Lü Peng, "Schema Correction and Cultural Criticism", 47–48.

⁵⁹ Johan Huizinga, *The Waning of the Middle Ages*, 189.

⁶⁰ Arthur C. Danto, *After the End of Art: Contemporary Art and the Pale of History*, translated by Wang Chunzhen (Jiangsu: Jiangsu People's Publishing House, 2007), 15.

⁶¹ Ibid., 142.

⁶² Jean Baudrillard, *The Consumer Society* (London: Sage Publications, 1998), 118.

⁶³ "Wang Guangyi Interview", *Phoenix TV,* Wang Guangyi's Studio, Beijing, aired 19 March 2006.

⁶⁴ Karl Popper, *The Open Society and Its Enemies* (Princeton, NJ: Princeton University Press, 2013), 456 (originally published in 1945).

⁶⁵ Louis Althusser, "Ideology and Ideological State Apparatuses (Research Notes)", translated and edited by Chen Yue in *Zhexue yu Zhengzhi – Aerdusai Duben* [Philosophy and Politics – The Althusser Reader] (Jilin: Jilin People's Publishing House, 2003), 369.

⁶⁶ "Guanyu Shehui Zhuy Shijue Jingyan – Wang Guangyi Fangtan Lu" [On the Socialist Visual Experience – Wang Guangyi Interview], in *Shijue Zhengzhixue: Ling Yige Wang Guangyi* [Visual Politics: Another Wang Guangyi] (Guangdong: Lingnan Fine Arts Publishing House, 2008), 201.

⁶⁷ Yan Shanchun, *Wang Guangyi Interview.*

⁶⁸ Ibid.

⁶⁹ Ibid.

⁷⁰ Huang Zhuan, "Shijue Zhengzhixue: Ling Yige Wang Guangyi" [Visual Politics: Another Wang Guangyi], in *Yishu Shijie Zhong de Sixiang yu Xingdong* [Ideas and Action in the Art World] (Beijing: Beijing University Press, 2010), 129.

[71] Yan Shanchun, *Wang Guangyi Interview*.

[72] Bertrand Russell, *A History of Western Philosophy*, Book I, Part II, Chapter XIX (London: Routledge, 2005), 159 (originally published in 1946).

[73] Aristotle, "On the Soul", in *Introduction to Aristotle. Second edition*, edited by Richard McKeon (Chicago: University of Chicago Press, 1973).

[74] Bertrand Russell, *A History of Western Philosophy*, 167.

[75] Ibid., 172.

[76] Yan Shanchun, *Wang Guangyi Interview*.

[77] Martin Heidegger, "The Origin of the Work of Art", translated by by Sun Zhouxing, in *Lin Zhong Lu* [Path in the Forest] (Shanghai: Shanghai Translation Publishing House, 2004), 1–7.

[78] "On the Socialist Visual Experience", 201.

[79] Yan Shanchun, *Wang Guangyi Interview*.

[80] Bertrand Russell, *A History of Western Philosophy*, 718.

[81] Zhou Guoping, *Nicai yu Xingershangxue* [Nietzsche and Metaphysics] (Beijing: New World Press, 2008), 142–84.

[82] Wang Guangyi, "Dui Sange Wenti de Huida" [Answers to Three Questions], in *Meishu* [Fine Arts] v. 3 (1988), 57.

[83] *Gongbulixi Tanhua Lu* [Ernst H. Gombrich Discussions], Meishu Yicong [Fine Arts Translation Series] v. 4 (1988), 5.

[84] Milan Kundera, *The Art of Fiction*, translated by Dong Qiang (Shanghai: Shanghai Translation Publishing House, August 2004), 7.

[85] Ernst Troeltsch, *Jidu Jiao Lilun yu Xiandai* [Christian Theories and Modernity], translated by Zhu Yanbing (Beijing: Huaxia Press, 2004), 16.

[86] Karl Popper, *The Open Society*, 410.

[87] Yan Shanchun, *Wang Guangyi Interview*.